THE CHAMELEON BODY

WITH TEXTS BY DAVID ALAN MELLOR AND ANTHONY SHELTON

LUND HUMPHRIES PUBLISHERS, LONDON

THE CHAMELEON BODY

PHOTOGRAPHS OF CONTEMPORARY FETISHISM
BY **NICHOLAS SINCLAIR**

First published in 1996 by
Lund Humphries Publishers Ltd
Park House
1 Russell Gardens
London NW11 9NN

The Chameleon Body: Photographs of Contemporary
Fetishism by Nicholas Sinclair
© Lund Humphries Publishers 1996

All photographs by Nicholas Sinclair
© The photographer 1996

Texts © The authors 1996

British Library Cataloguing in Publication Data
A catalogue record for this book is available from
the British Library

ISBN 0 85331 696 1

Designed by Chrissie Charlton & Company
Printed in Great Britain by
BAS Printers, Over Wallop, Hampshire

Distributed in the USA by
Antique Collectors' Club
Market Street Industrial Park
Wappingers Falls
NY 12590
USA

For my mother and father – an artist and an actor

CONTENTS

ACKNOWLEDGEMENTS

My grateful acknowledgements to:

Dr Rachel Armstrong
Judith Burns
Chrissie Charlton
Robin Dance
David and Kaisu, The Torture Garden
E. Garbs, Brighton
Roy Gardner
Paul Gumn, BAS Printers
Amy de la Haye, Curator for Twentieth-century Fashion,
 Victoria and Albert Museum, London
Mike Jones, Keeper of Conservation and Design,
 Brighton Museum and Art Gallery
Tony Joss
Lois Keidan, Director of Live Arts,
 The Institute of Contemporary Arts, London
Dr David Alan Mellor, Reader in Art History,
 University of Sussex
Lucy Myers and Lara Speicher,
 Lund Humphries Publishers
Anthony Shelton, Keeper of Ethnography,
 The Horniman Museum, London
Martin J. Short, Photographic Assistant
Louise Tythacott, Curator of Ethnology,
 National Museums and Galleries on Merseyside
Tim Woodward and Tony Mitchell,
 Skin Two magazine
Frank Youngs

Nicholas Sinclair

PHOTOGRAPHIC CREDITS

Assistant to the Photographer:
Martin J. Short

Illustration 4:
Outfit by Bi-design

Illustration 5:
Outfit by Christine Bateman

Illustration 6:
Outfit by E. Garbs
Resin mask by Suzie Le Brocq
Tattoo design by Ian Lester

Illustration 7:
Head harness by E. Garbs

Illustration 9:
Outfit by Suzy

Illustration 14:
Outfit by Anthony Gregory
Styling by Issy Lane

Illustration 22:
Outfit by Nicola Bowery

Illustration 23:
Outfit and styling by E. Garbs

Illustration 26:
Outfit by Nicola Bowery

Illustration 27:
Helmet by Anthony Gregory
Styling by Issy Lane

Illustration 32:
Head harness by E. Garbs

Illustration 34:
Outfit and styling by E. Garbs

Illustration 38:
Outfit by Nicola Bowery

Illustration 40:
Outfit by Anthony Gregory
Styling by Issy Lane

Illustration 41:
Outfit and styling by E. Garbs

Illustration 42:
Outfit and styling by E. Garbs

Illustration 43:
Outfit and styling by E. Garbs

Illustration 44:
Outfit by Anthony Gregory
Styling by Issy Lane

Illustration 45:
Outfit by Suzy

Illustration 48:
Outfit and styling by E. Garbs

Illustration 49:
Outfit by Nigel Woodrow

Illustration 50:
Outfit by Anthony Gregory
Styling by Issy Lane

Illustration 51:
Helmet by Anthony Gregory
Styling by Issy Lane

Illustration 52:
Outfit and styling by E. Garbs

Illustration 53:
Outfit and styling by E. Garbs

Illustration 57:
Outfit by Christine Bateman

Illustration 60:
Outfit and styling by E. Garbs

Illustration 61:
Outfit by Suzy

Illustration 64:
Head harness by E. Garbs

PREFACE Nicholas Sinclair

The photographs for *The Chameleon Body* originated when I was asked to take a portrait to be included in the catalogue for the exhibition *Fetishism: Visualising Power and Desire*. This exhibition, held at Brighton Museum in the spring of 1995, was the first in Britain to adopt fetishism as a subject with both a history and a place in our contemporary culture, and my brief was to illustrate fetishism as it is understood in the 1990s. Fabian, masked and winged as the Angel of Death, and his partner Nigel, enclosed in a sensory-deprivation suit, were my subjects, their outfits designed by Erisian Garbs.

Although I was on unfamiliar ground during this first shoot, my work with artists, with actors and actresses and with the European Circus enabled me to combine a degree of understatement in my approach to the photographs with an intimacy and clarity which I felt these highly charged characters demanded. Instinctively I knew that a restrained image would be more effective than any attempt to sensationalise what I was seeing. The results of this shoot led, at the Museum's request, to an exhibition of portraits, and this in turn led to discussions with Lucy Myers, Editorial Director at Lund Humphries, about extending the work into a book.

I always conceived the book as a cohesive sequence of portraits and not as an attempt to document the various interpretations of the word 'fetish'. So in my research it was a concern for character and for the resonance of that character when masked or hidden or in fetish persona which drew me to photograph particular individuals. But the photographs also focus on the body and on the body's capacity for change and transformation. These changes can be minimal and discrete or they can be extreme, defiant and transgressive acts, and my aim was to show the different degrees and levels of transformation. I also began early on in my work to be aware of a connection between fetishism and performance art. In both areas the body is seen as a 'performance space', or as a vehicle for self-expression, with the individual having the control to use this 'space' as he or she chooses. With institutions such as the ICA creating a platform for a new generation of performance artists, I wanted to include some reference to performance in the portraits and perhaps the most eloquent example I found was in the work of the Italian performance artist Franko B. Using his own flesh and blood, Franko creates a language with which to express alienation and trauma, describing his work as 'a metaphor for the fragility of the human condition'.

Finally I wanted to show how in the late twentieth century there is a return to tribal or so-called 'primitive' practices, as seen in the Modern Primitives. The Modern Primitive movement is discussed by Anthony Shelton in his essay 'Fetishism's Culture'; the two exponents of the movement whom I photographed are Xed Le Head and Darryl Carlton, a European and an American respectively. Fetishism draws from a wide range of sources for its inspiration – historical, contemporary and cross cultural. It is this diversity which I explore in the photographs.

THE CHAMELEON BODY David Alan Mellor

(Numbers in brackets are illustration numbers)

Sinclair's sitters are antagonistic, as they shout or remain sulkily mute in their circles of Hell, like the hostages of Demogorgon and his fatal sisters. They appear to be in some perpetual contention with the mundane when we encounter them underground and uncomfortably meet the basilisk gazes of Peter Mastin (11) and Mark Garbs (6), with their look of armed, fearsome resentment. They bear their 'badges of subjection'[1] which act as divinatory signs: Jed Phoenix (10), for example, is ringed by her lip and ringed again on the front of her costume; rings tethered to her flesh, as she appears with cast-down eyes before her lover Joss, her flamboyance inducing a returning circuit of 'aggression to myself'.[2] On such bravado bodies the crescents of Astarte, the pendants, tears of pearl and highlit studs become spots of light whose shines play around Sinclair's series of portraits. Carl Russell's icy knuckles (4) rise like serial hills from the ashen seas of the moon, disposed as surging bone beneath the skin, triangulated by the metallic studs on his shoulder pads.

Such cutanaeous tares become badges on the skin – manifestly so with Darryl's votive charms, decals and transfers of tin (63). Iron in the soul and in the skin and in the body, too: 'Old heroes had bits of metal outside them (knights), but modern heroes have bits of metal inside them … It is the body itself that has to be transformed, precisely because there is a problem in the symbolic transmission [of manliness] … If the attributes of manliness are not passed on in symbolic ways, men try to grasp them "from the outside" and the symbolic structure has to be literally injected.'[3] A parade of sectarian markings that prove the restoration of a certain 'manliness' is slyly disclosed in these pictures and exceeds mere metallisation. Here are to be found the dark star on Lester's shoulder (7); the temporary veil of blood and inking on Franko B's head and body (25, 28); a sponged deposit waxily resisted by the fat of his Kurtz-like head; and the ashy burn or bruise which brands Scorpio's forehead (54). This universal gathering of body modifications spills global and communal signs into a scavenging will to individual customising in the nether worlds of the West. This is our first-world tribalist and 'primitivist' annexation of the history of colonial markings which recirculates all the bad trophies – Alex Binnie (19) as a squatting Nuba tribesman; Mark (31) cropped as a shrunken head, the lips apparently sewn together by metal rings, and Dickie Dick (16) as a white European bearer of Maori tattoos to his head.

Strategies of the grotesque and carnivalesque are marked by Sinclair and at times he becomes complicit with them. The great instance in these photographs is the animalisation of Christine Bateman (5), where a feline physiognomy is carried forward into Sinclair's portraits of her. Baudelaire pre-imagined her gaze: 'that blasé look, that vaporous look, that voluptuous look, that wicked look, that sick look, that cat-like look, infantilism, nonchalance and malice compounded'.[4] A moue, but quieted, the cat that has got and, perhaps, bitten its own tongue. And reproachful too; the reproach of a minx harnessed by herself, hobbled by

a steel bar across her breasts like a barrier, a burden and a yoke to parade. Another animal – Xed Le Head (48) – with a covering which is part reptilian tattoos, part the bridled, muzzled hound, throws back his head and gives a howl that cannot escape his hood. With his dreaded hair, his scales and his serpentine thorax, Sinclair represents Xed Le Head as a rising sequence of animalised textures from across the species divide in a 'Satyr-like conflation of human and animal'.[5] This selection of portraits ends with a horned human term – that is, a statue marking a boundary point – as the reader and viewer exits from this very knowing masquerade, with Lester (64) standing in as a goat-man: an identificatory guise of the Satyr. The orgiastic and phallic revelling aspect of the original Greek Satyr plays is renewed in the coarse bodily presentation of the bellowing of Xed Le Head – a wild man, 'a wild half-human being'.[6] Lester (7) is crouched and still: Dickie Dick, on the other hand, is in an ecstatic dance, with a curative and cathartic goal for this clenched and stigmatised self-healer who might become re-vivified and nimble (52, 53).

In her book *Body Criticism*, Barbara Maria Strafford writes on hybridity in the representation of the monstrous, both through the agency of animalisation and the manufacture of grotesque composites. She describes this as 'the visual equivalent of the … Menippean satires'.[7] This places her in alignment with those annexations of Menippean rhetorics of satire by critics and historians who have theorised the carnivalesque, particularly Mikhail Bakhtin and Julia Kristeva. The sexual masquerade, of doubling and masking – so as to make identity equivocal – is operating here as a frame of carnival performance for those Sinclair has portrayed. Joss Munro, for example, is phallicised in a transgendered manner which disavows her breasts and nipples as legible and reliable secondary sexual indicators (2). Sinclair has re-formed her in a resemblance to the creatures in Bacon's *Study for Three Figures at the Base of a Crucifixion* (1945), with an extended, growing head from an erectile neck. There is a riot of metamorphic reptilian bodies present as Alexandre Lembrechts's back carries the tatooed likeness of the Alien predator (3). Its Dalí-esque cranium is superimposed on his skin and extends up between his shoulder blades to meet the lock of black hair descending towards it, formally rhyming with the curve of his gristled and multi-ringed ear.

Aside from these re-codings of Joss's and Alexandre's bodies, the category of 'depraved perspectives', in Jurgis Baltrusaitis's phrase, perhaps does not universally operate in Sinclair's photographs. 'The optical depravations known as anamorphoses and aberrations (in the astronomical sense) which, allowing things to be seen other than they are, have given rise to legends of forms … They are all the product of the same poetical mechanism.'[8] Sinclair's persistent naturalism, in his disposition of these bodies, is regular, centralised and symmetrical. He avoids, by and large, these distorted 'legends of forms'. Instead, the spatial

relations he generally constructs are not those identified by Victor Burgin as 'perverse',[9] whatever the denotative meaning of the bizarre bodies pictured might signify. This disentanglement of form and content gives rise to a tension. He purposefully disappoints through a lack of sensationalist view which the spectator of his photographs might have expected. The monumental representation of Darryl (63); Ralph's level and unemphasised head-on portrait (1) suggest as much. As photographed scenes these are – generically – interior portraits, sombre and darkened ones. Here are depicted private states that have been stabilised by Sinclair. These self-absorbed spectacles of nihilism operating about the exhibitionist body have had subtracted any manic interiority. The majority are at rest, a few yowling and dancing, but most are quelled by Nicholas Sinclair's canny refusal to be caught up in their fantasies.

But occasionally, the modifications these individuals have made to their own proper bodies' phenomenological appearance – through markings, torsions of and incisions into the flesh – do find themselves answering Baltrusaitis's nomination of spatial depravity. For example, Nicola Bowery (38), in her sister's dressing room, echoes Eliot's 'Game of Chess' from *The Waste Land* – with its claustrophobic, multiplied and mirrored versions of the suffering woman on display. Spatial depravity is, perhaps, present in the hyperbolic look of Nicola Bowery; a pose which is a perpetual blur. It is a matter of self-fashioning, too, as her left eye-lid and brow are made into a widened and cruel self-interrogation mark by darkening and amplifying the flesh above the eye – through cosmetics – a drawn mimicking of her pulled lower lip wrenched down by a G-clamp.

The Lady of Shalott is acted out by them in a Whitechapel council flat, as Christine Bateman and Nicola Bowery stand between mirrors in their dressing room. Sinclair has constructed a narcissistic 'palace of art', in collusion with these sisters, a certain existential zone which can be identified with Jan Gordon's typology of decadent spaces: '… to remain on a magic island is to live in an inauthentic fairy realm, where mirrors prompt a masturbatory aesthetic…[and] the misty aesthetics of self-reflection … This is an art that has self consciously turned back upon itself, confronted the aesthetics of fatigue and the ontology of boredom.'[10] They are locked up, like the Lady of Shalott, in a tower block, constrained by finely articulated bony girdlings, like those self-inflicted across Christine's snout, with keys hanging unused and zips to lower lips closed (5). The majority of Sinclair's photographs, as they appear here, have an obsessive opacity in their delineation. But his portraits of the sisters mark a relinquishing of this abstinence from any depiction of interiority and overt expressivity. Nicola and Christine present themselves as the victims of their mirrors, doubled and tripled, but skinless. They possess no tegument, no coverings such as those Xed Le Head, Dickie Dick and Daryl Carlton have crafted as aggressive

protections. Nicola Bowery's plastic piping and soldering wire, wrapped around her body and head, outline this skinless state of psychic insufficiency and vulnerability, as does Xed Le Head's mock umbilical cord (34).

In a masquerade of masculinity, Mark Garbs's diaperised youth is pelted and 'fronted', aproned and starred in the kind of boilerhouse décor where the triumphal past of the industrial and mechanical – emblematised, say, in the early twentieth-century photographs of Lewis Hine's fitters – once held male bodies secure. Garbs's coverings mimic the missing traits of prowess that once accompanied the heavy, physicalised world of labour and noble pursuits. He asserts himself simultaneously as samurai and foundryman, knight and knacker's yard assistant … occupations now defunct or rare, that have ebbed away to the spidery old corners of the world or have been forcibly re-invented as compensatory habits. Sinclair shows the anachronistic phantoms of an age that is leaning forward into virtuality, as he portrays those who inhabit a phantasmagoria of pompous, picturesque and over-assured bodies. They register a stylised plenitude and magic that never was – except in the gothic picturesque, that resource for the powerless who will their own ostentatious stigmatisation.

Barbara Maria Stafford has coined the phrase 'epidermal barbarism'[11] as a way of characterising the stained and mottled bodies of the sickly and stigmatised of the Enlightenment era; those that bore indications of the bizarre, the excluded and the diseased. This disruption of the skin (a skin, that is, of culture as well as that of human bodies) presents the cultural diagnostics of 'a broken veneer'.[12] Dickie Dick (52, 53) is, perhaps, the most spectacular instance of this 'epidermal barbarism'; in his tattooed Maori-derived overlay, his multiple piercings and, most incisively, his illusionistic self-impaling, he takes up a pose of clowning horror. His body is skewered and the horror that arises from his transverse spearing goes deeper than the surface of the skin: his body is pinned down, transfixed by this steel rod. Dickie Dick – loathed and derided by his peers and community as the child of an SS volunteer – is struck through by history and repeats that disaster, elaborating his suffering by pinioning himself as a specimen of the historically accursed. Despite the trickery of the spear, he attains the sculptural pathos of heroic suffering, a perverse version of The Dying Gaul, an alive and dancing Lucifer whom God has hit by a thunderbolt and expelled. Dickie Dick, along with Paul Joseph Addison-Handley (35) and Peter Mastin (37) – the latter fully adopting a satanic appearance – stand as pantomimes of despotic authority and abased punishment in ways that scorn the hazard of their future identities.

Footnotes

1 D. Leader, *Why Do women write more letters than they post?*, Faber and Faber, 1996, p.158

2 Dickie Dick, interview with the author, Brighton, 29 August 1995

3 Leader, op. cit. pp.28-9

4 G. Baudelaire, *Oeuvres Complètes*, ed. C. Pichois, Gallimard, Paris, 1961, p.1256; quoted in A. Lingis, 'Lust', in *Speculations after Freud: Psychoanalysis, Philosophy and Culture*, ed. S. Shamdasani and M. Munchsu, Routledge, 1994, p.136

5 A.D. Napier, *Masks, Transformations and Paradox*, University of California, 1986, p.70

6 ibid. p. 63.

7 B.M. Stafford, *Body Criticism*, MIT Press, 1991, p.270

8 J. Baltrusaitis, *Aberrations*, MIT Press, 1989, p.vii

9 V. Burgin, 'Perverse Spaces', in *Interpreting Contemporary Art*, ed. S. Bann and W. Allen, Reaktion Books, 1991, pp.124-38.

10 J.B. Gordon, 'Decadent Spaces: Notes for a Phenomenology of the Fin de Siècle', in *Decadence and the 1890s*, ed. I. Fletcher and M. Bradbury, Edward Arnold, 1979, pp.31-2

11 Stafford, op. cit. p.289

12 ibid. p.329

THE PHOTOGRAPHS

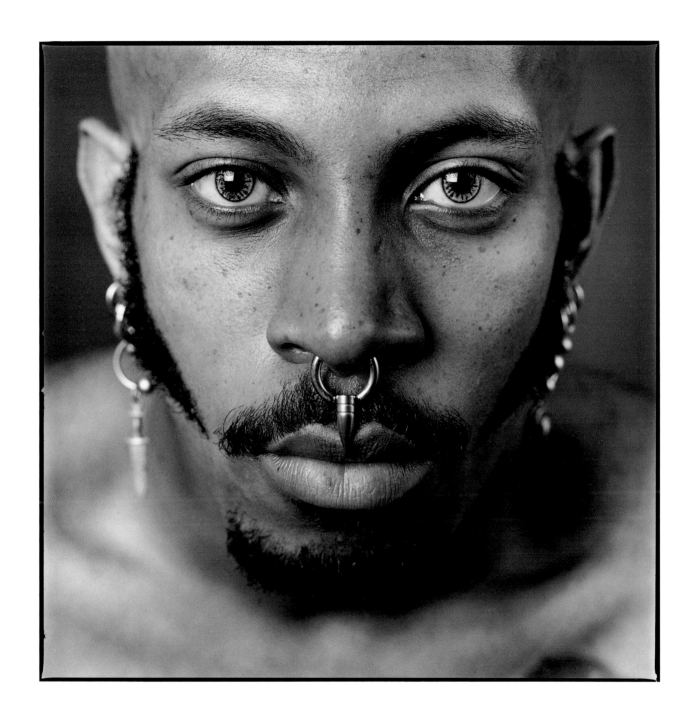

l Ralph

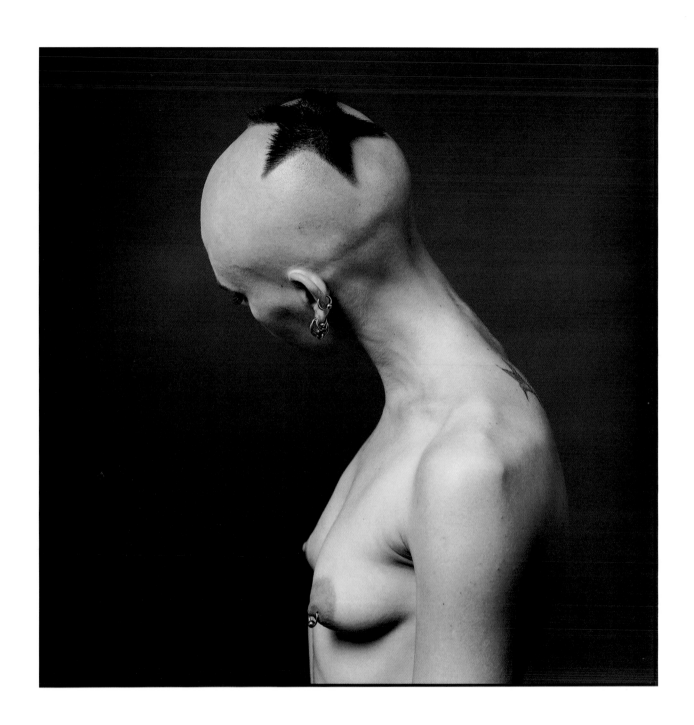

2 Joss Munro

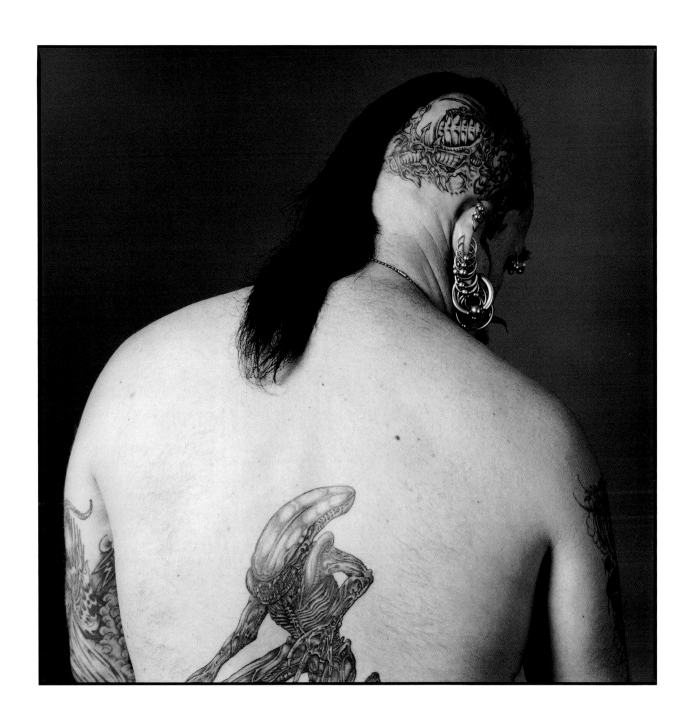

3 Alexandre Lambrechts

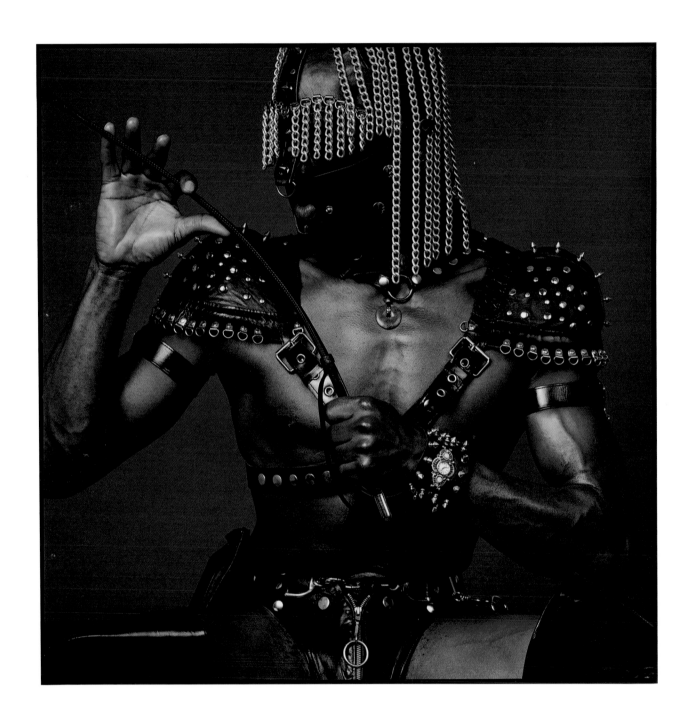

4 Carl Russell

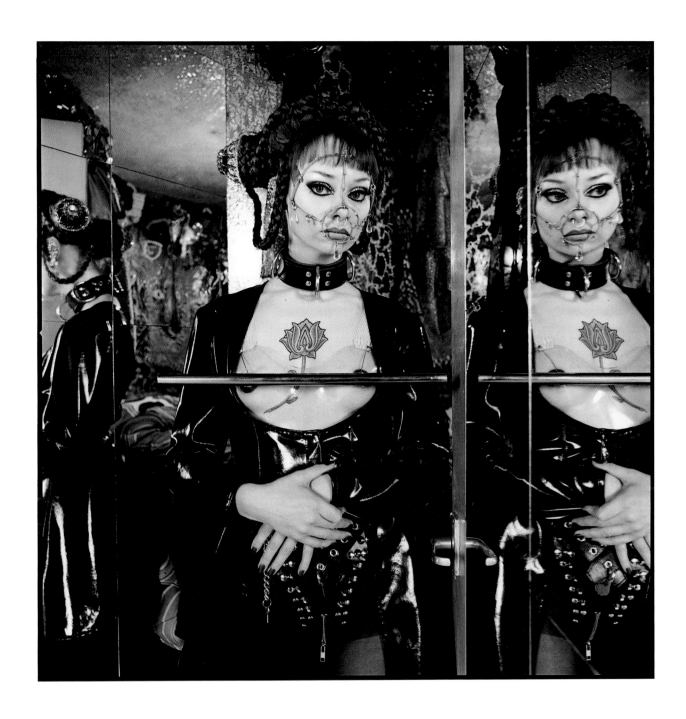

5 Christine Bateman

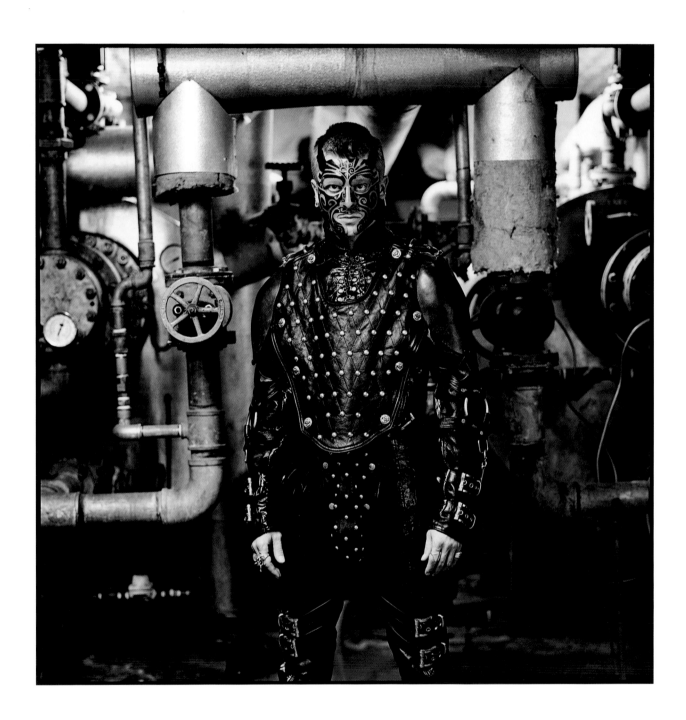

6 Mark Garbs

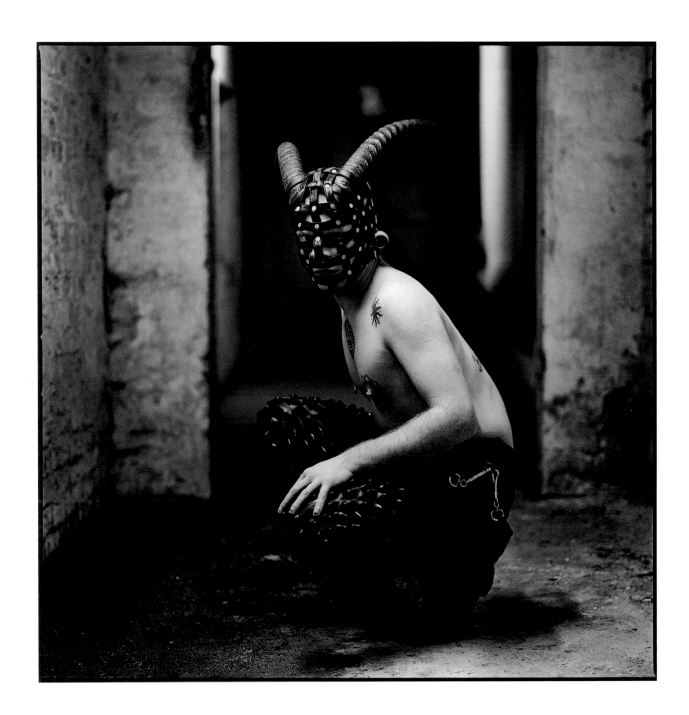

7 Lester

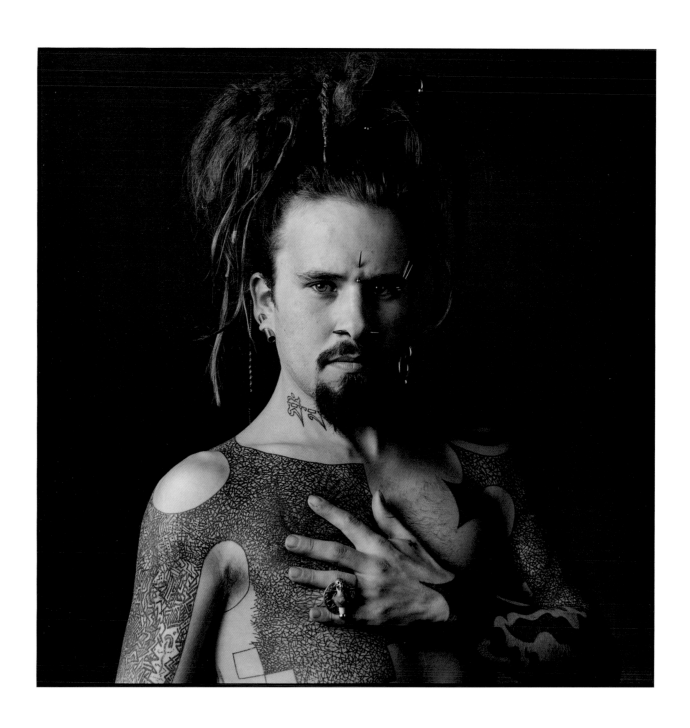

8 Xed Le Head

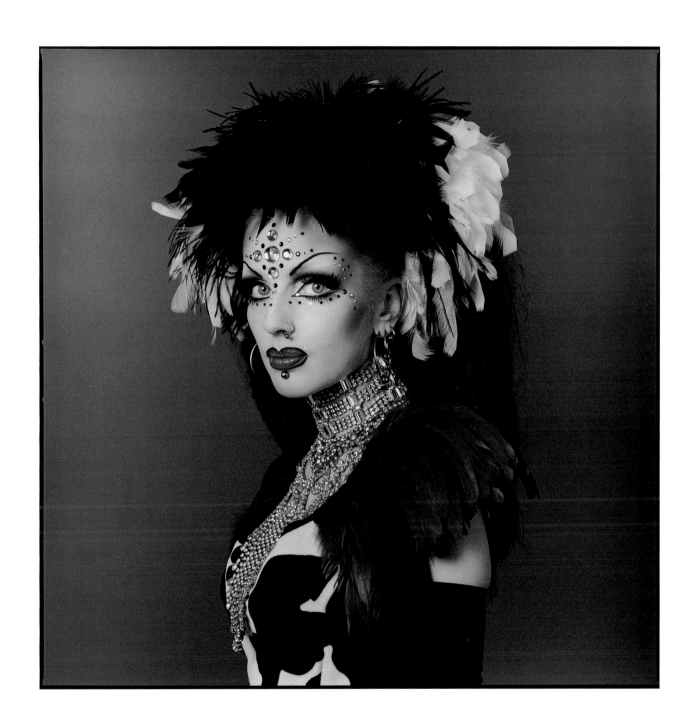

9 Suzy

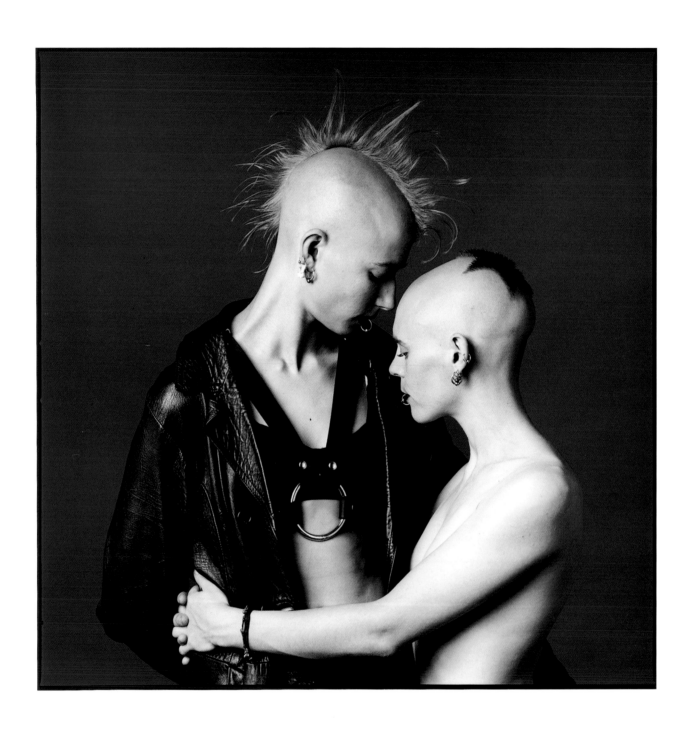

10 Jed Phoenix and Joss Munro

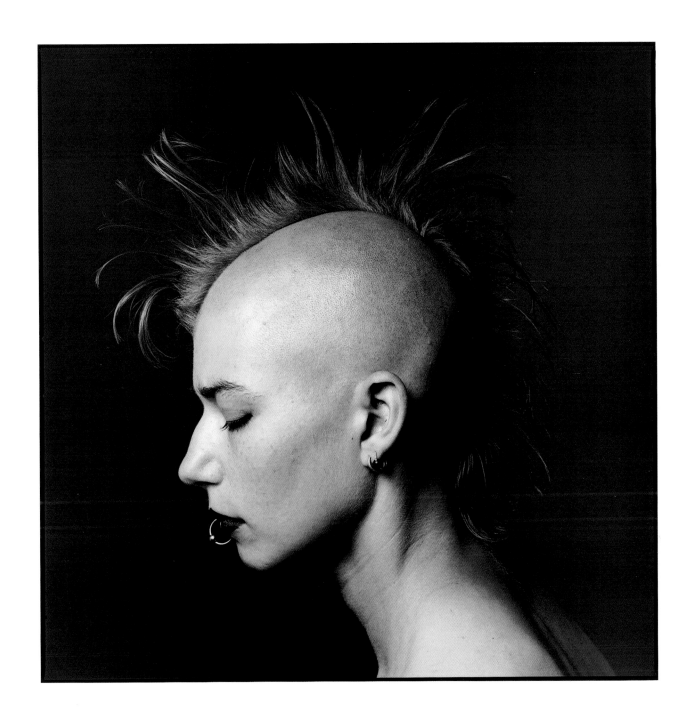

11 Jed Phoenix

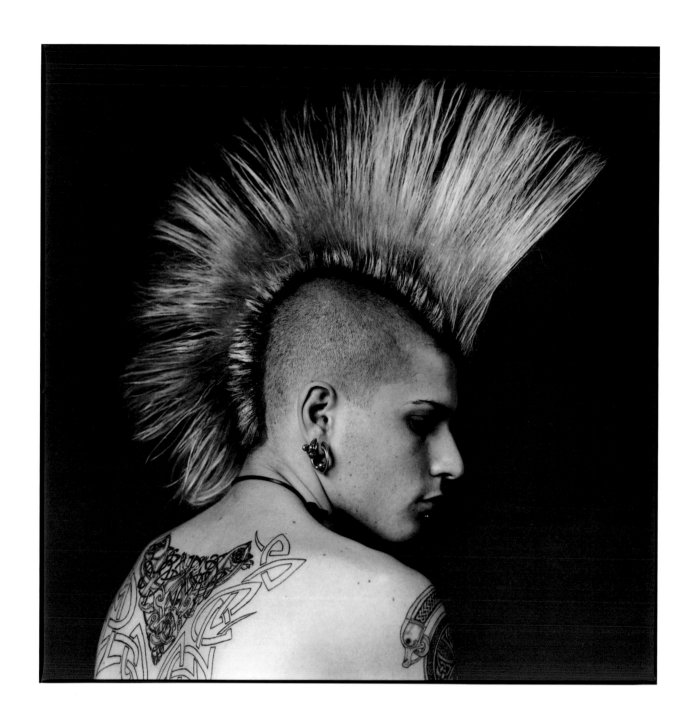

12 Steven Jasper

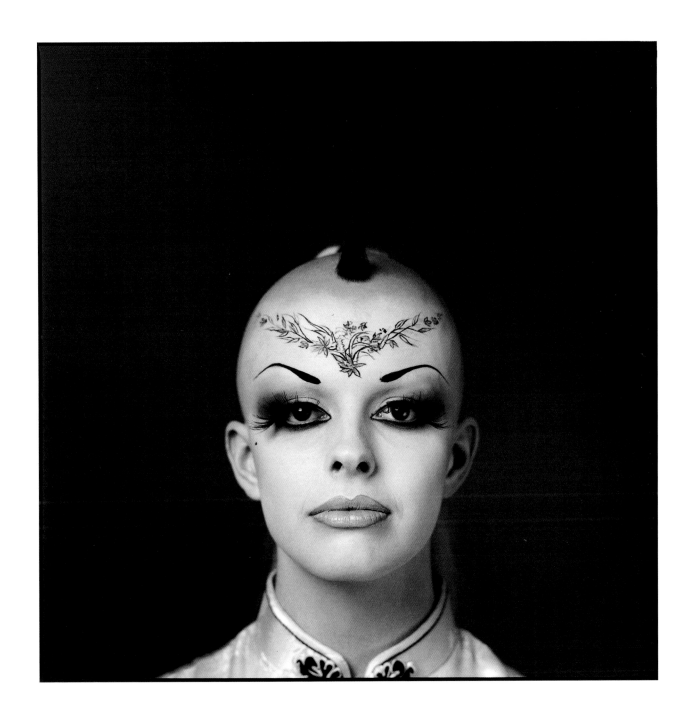

13 Kate Birrell

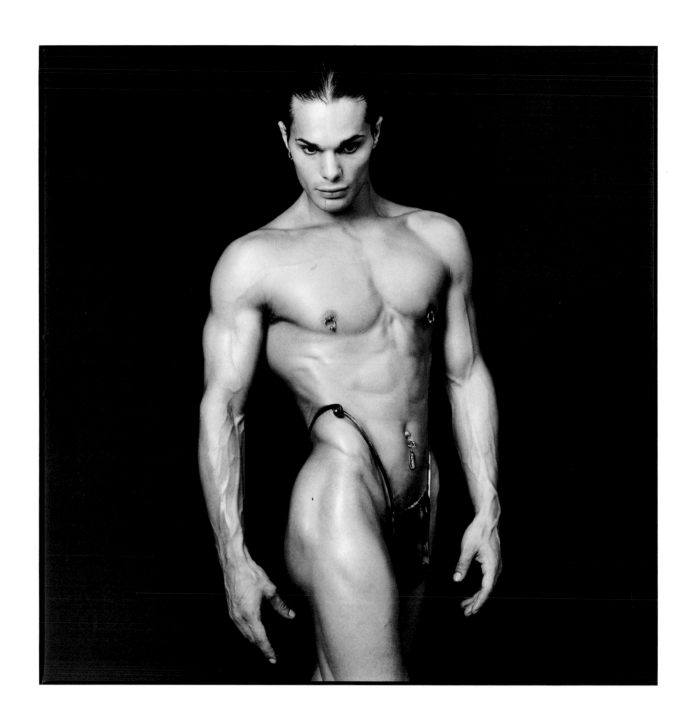

14 Enzo Junior

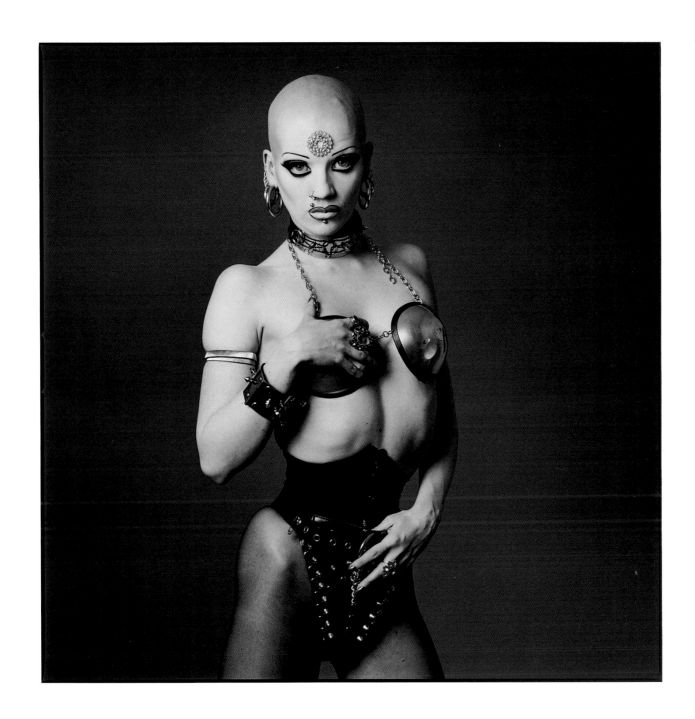

15 Polly

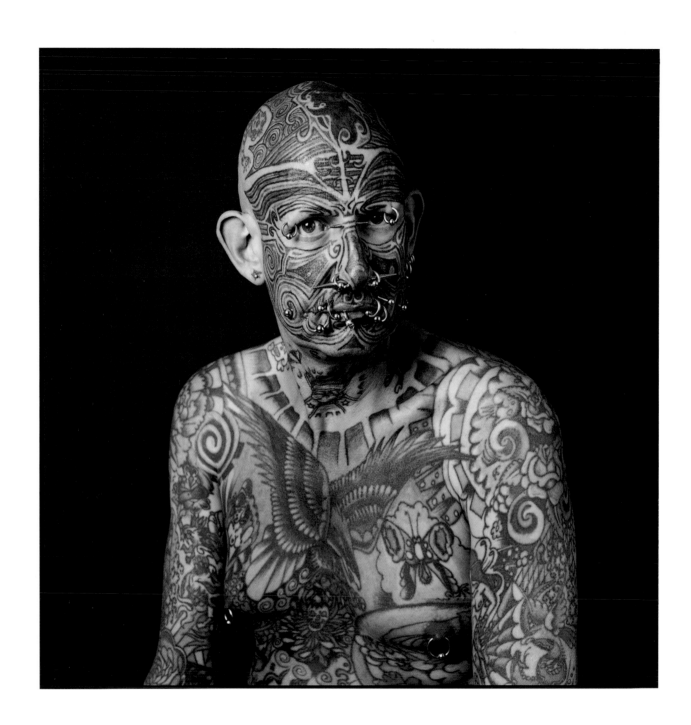

16 Dicky Dick

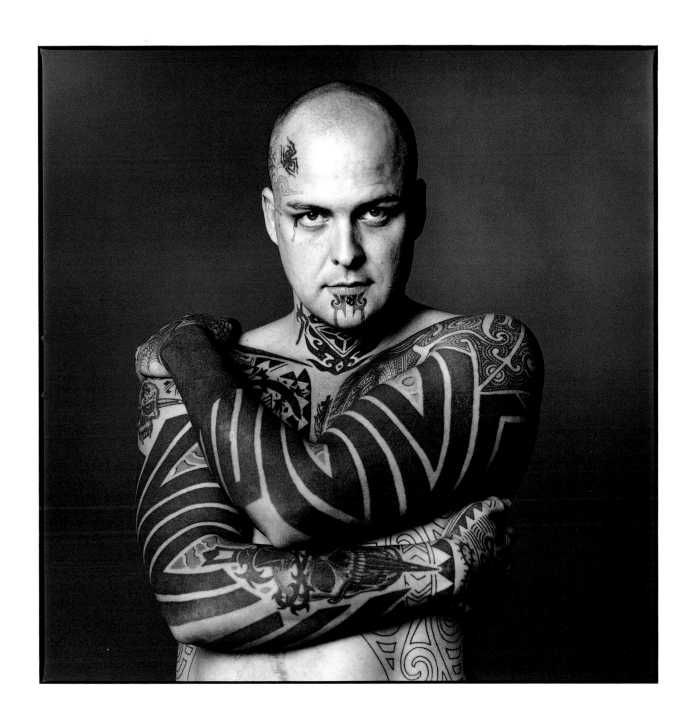

17 Ron Athey

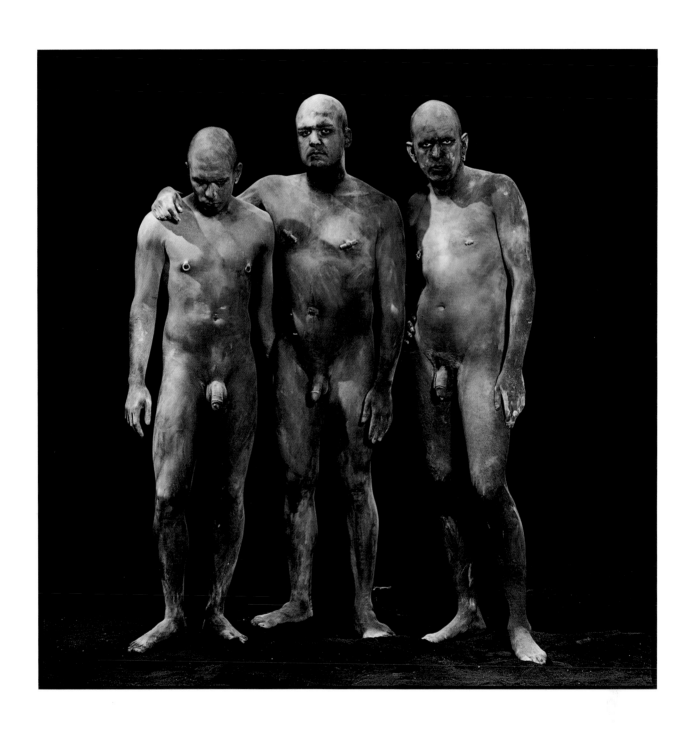

18 Brian Murphy, Ron Athey and Alex Binnie

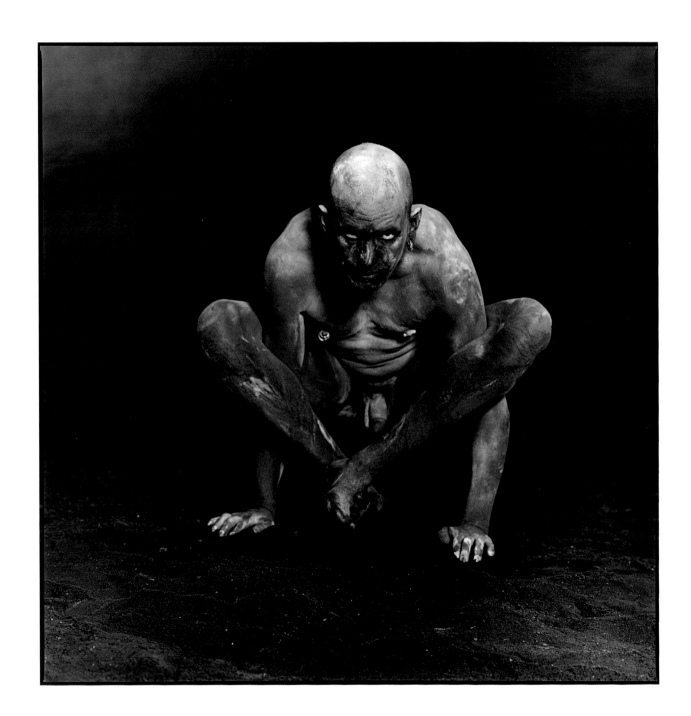

19 Alex Binnie

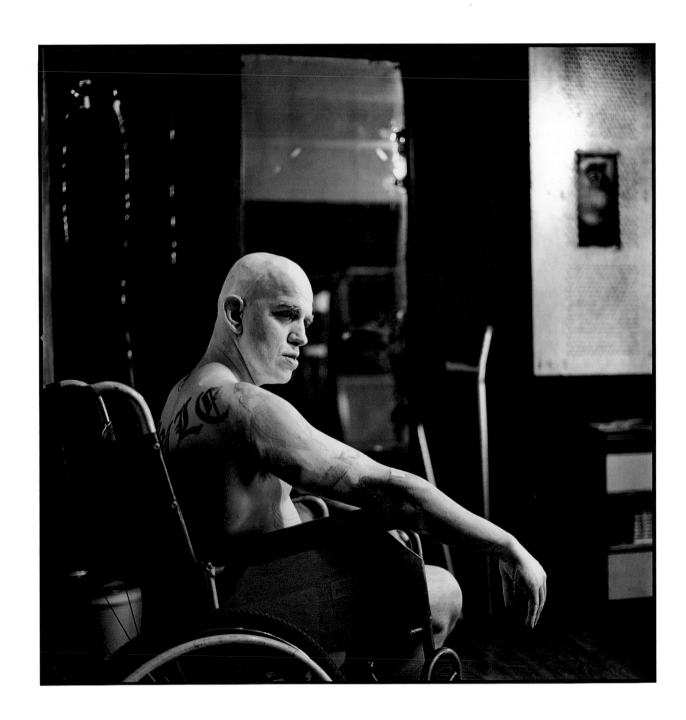

20 Franko B

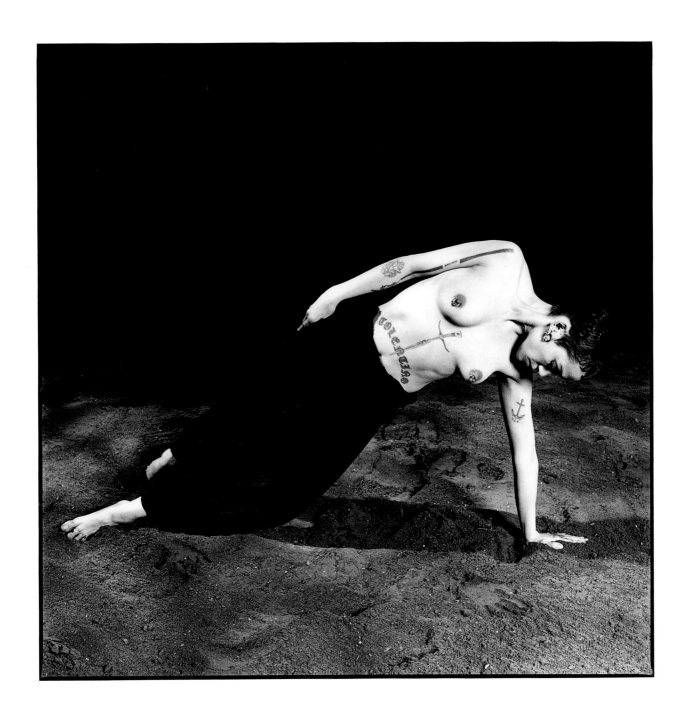

21 Julie Tolentino Wood

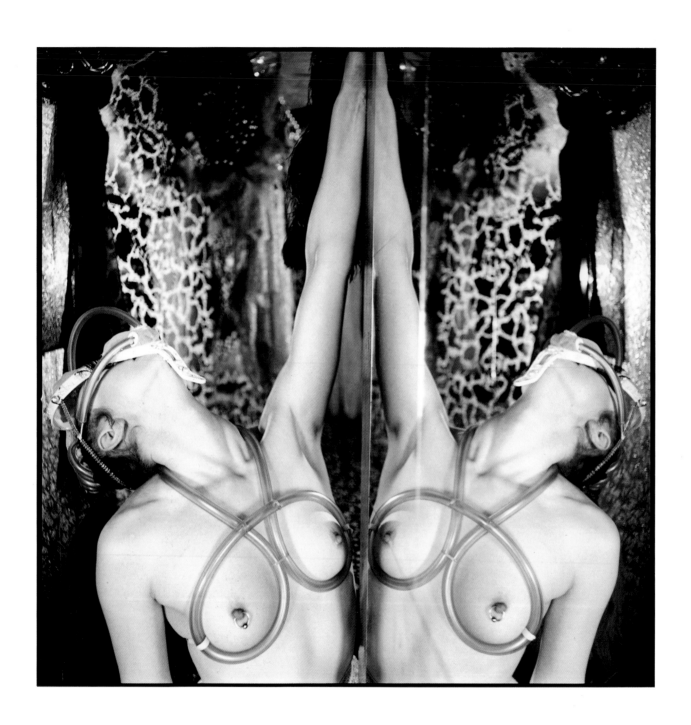

22 Nicola Bowery

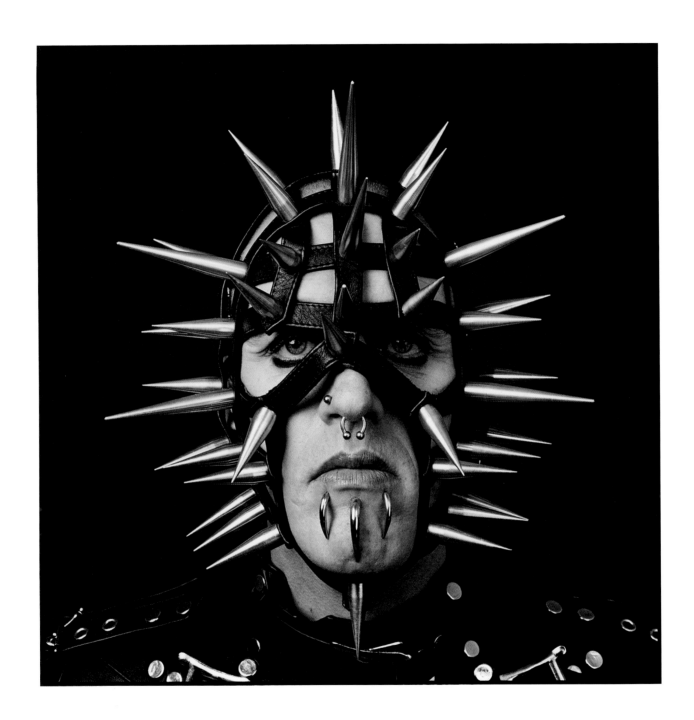

23 Nigel

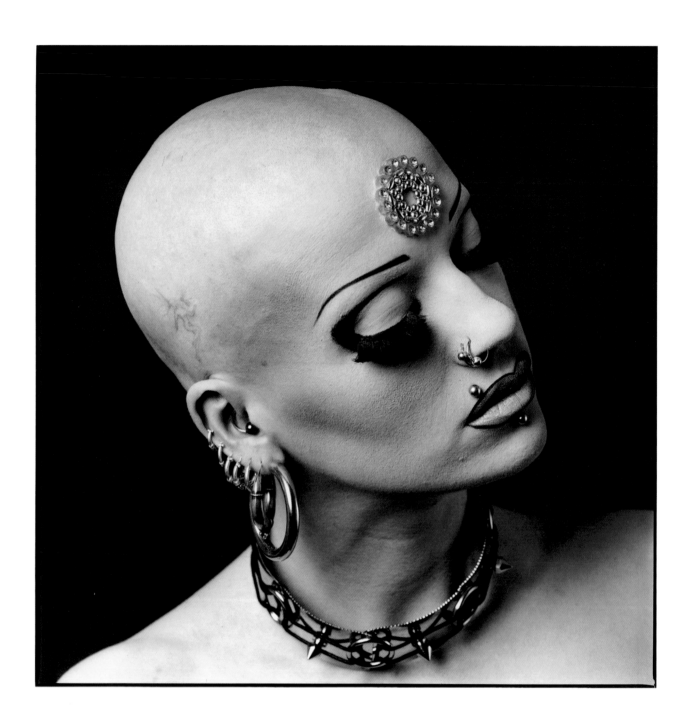

24 Polly

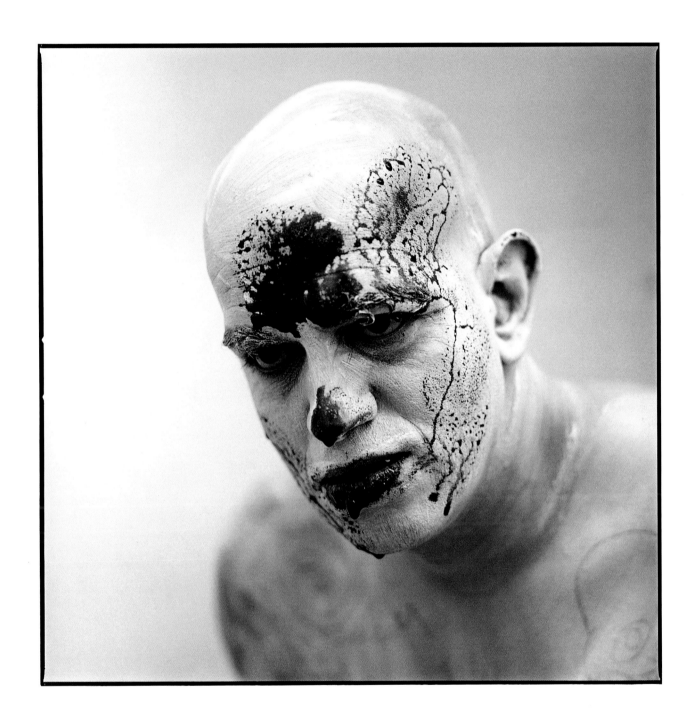

25 Franko B

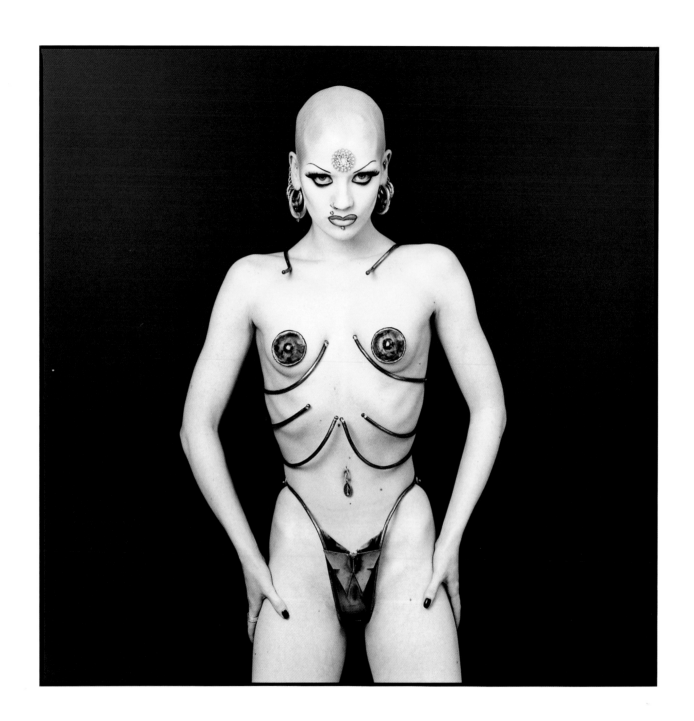

26 Polly

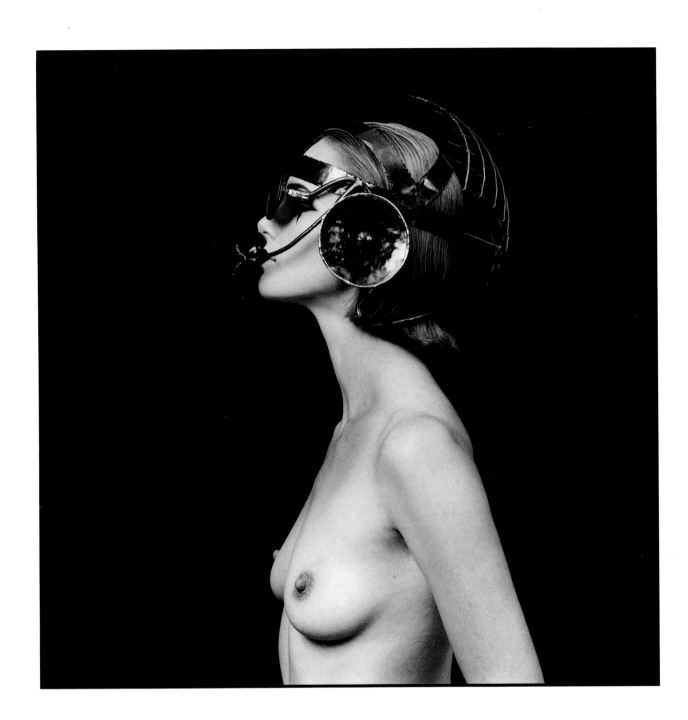

27 Fia Berggren

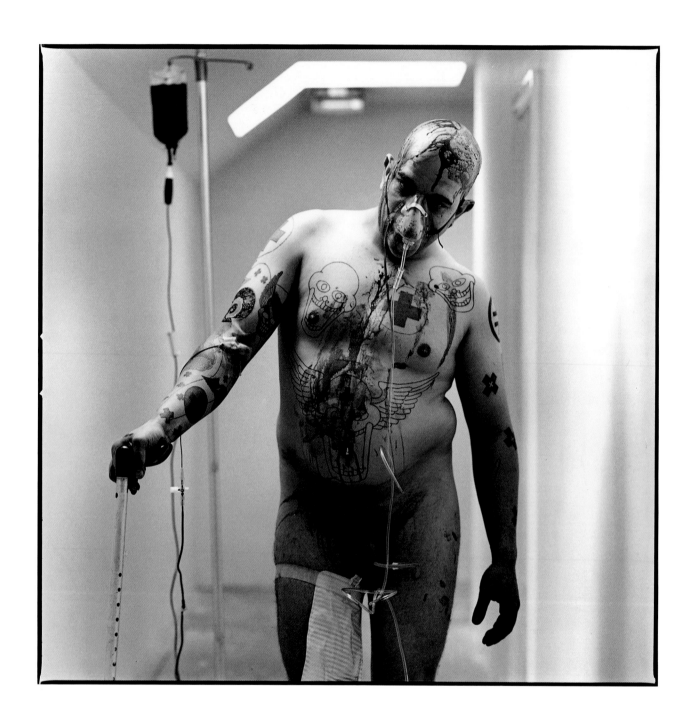

28 Franko B

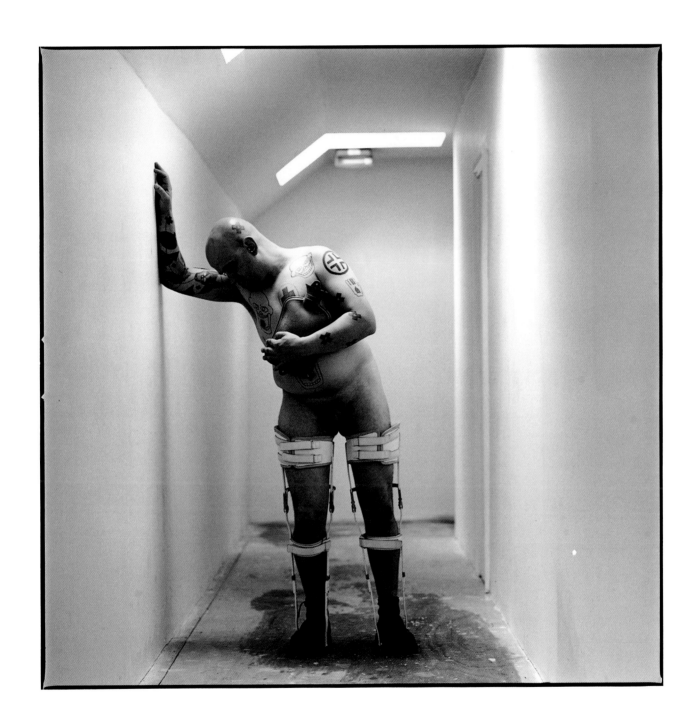

29 Franko B

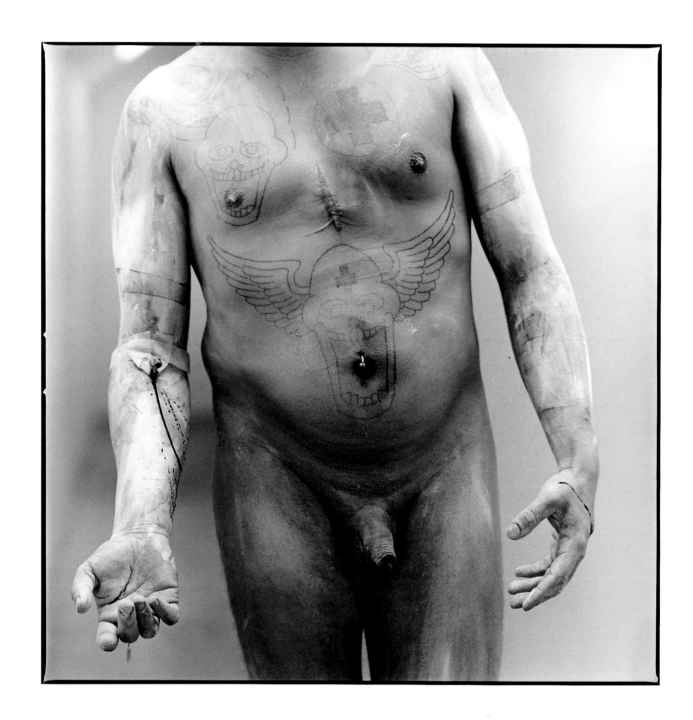

30 Franko B

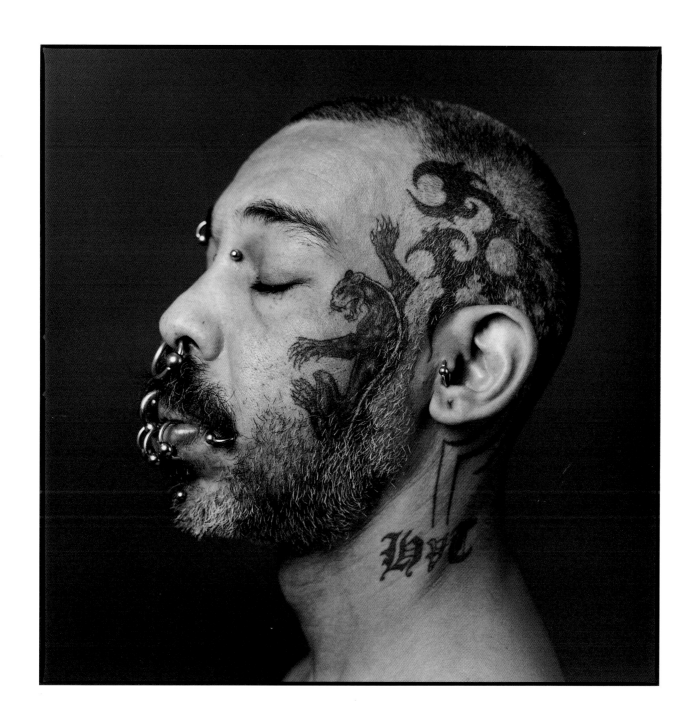

31 Mark

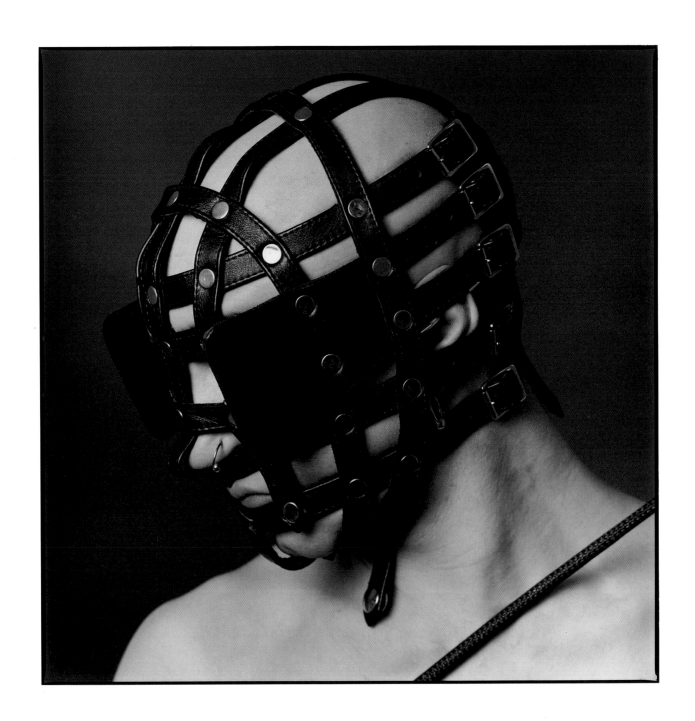

32 Billy

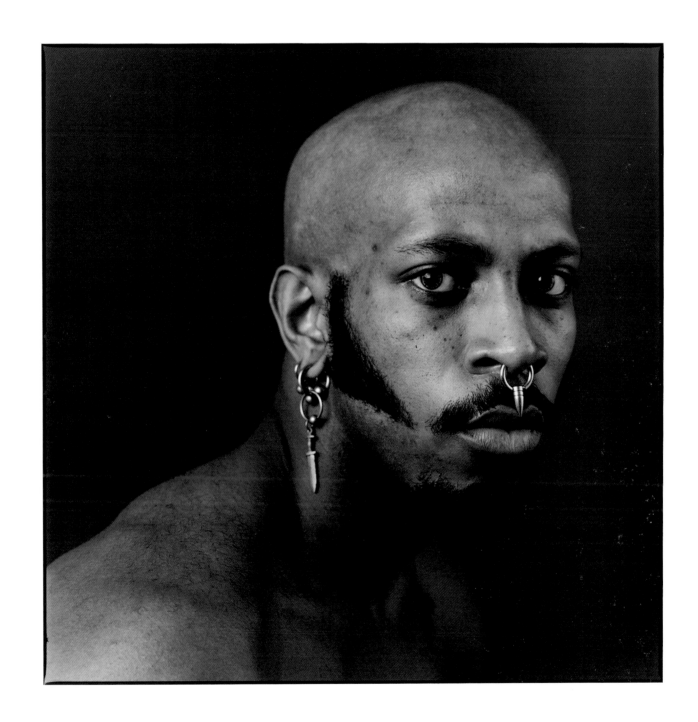

33 Ralph

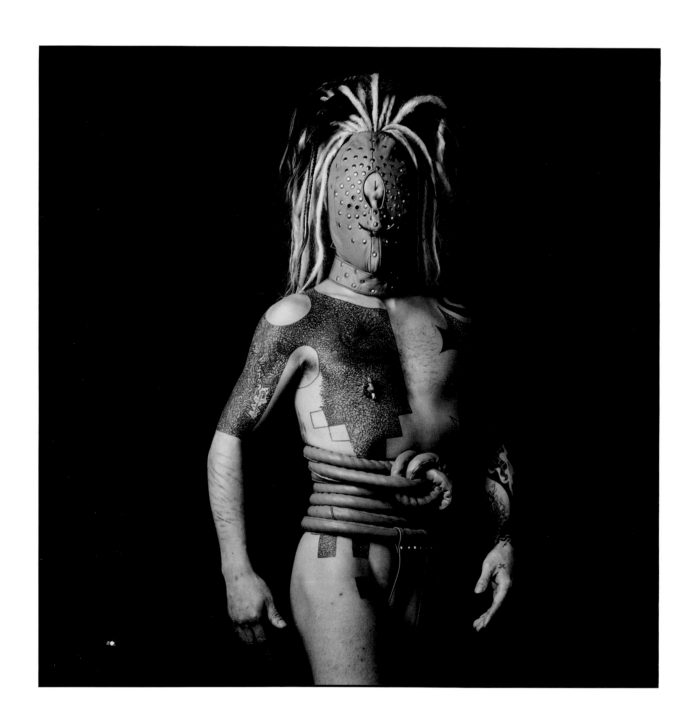

34 Xed Le Head

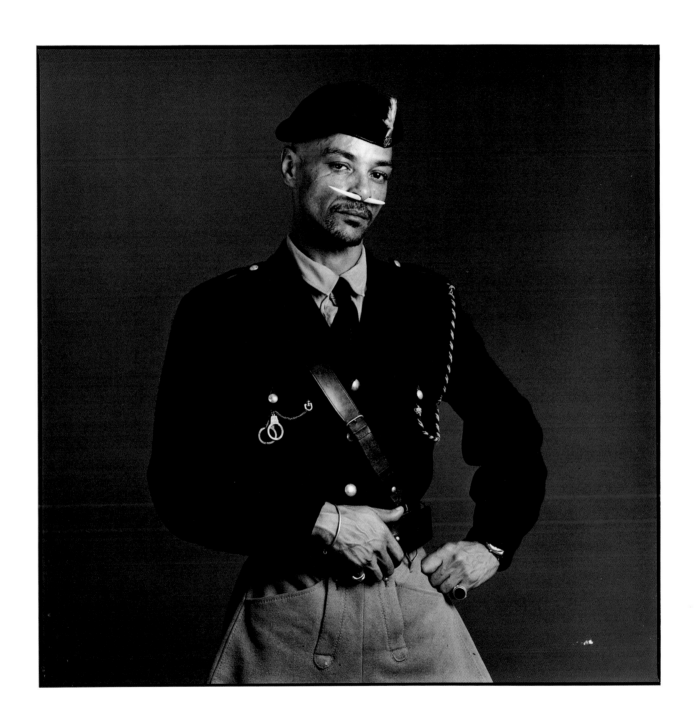

35 Paul Joseph Addison-Handley

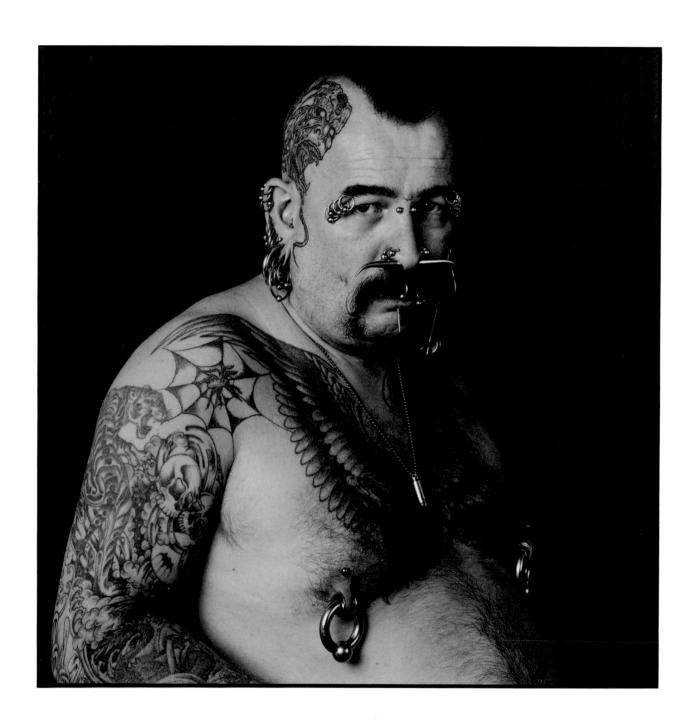

36 Alexandre Lambrechts

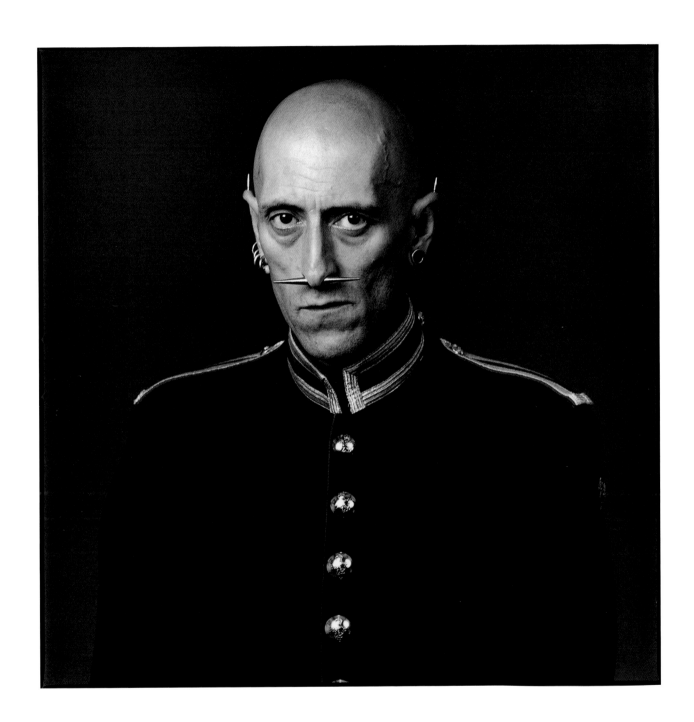

37 Peter Mastin

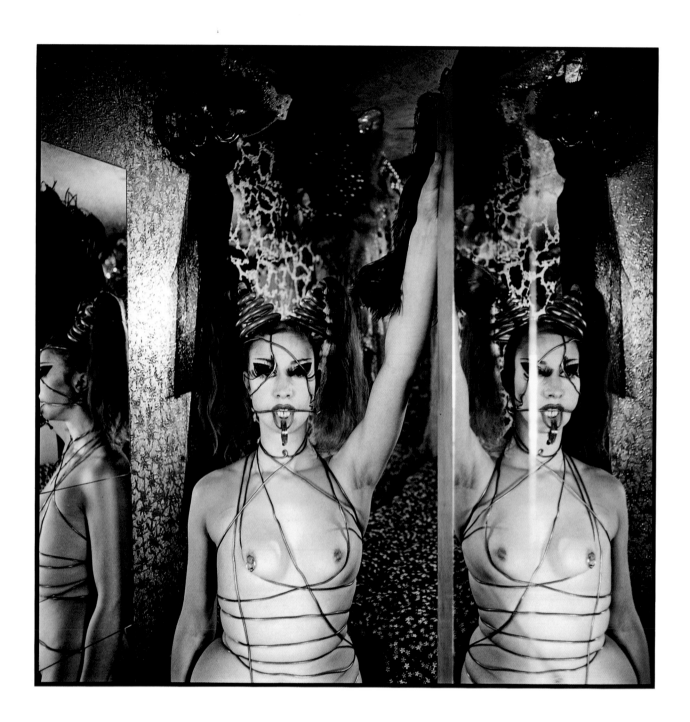

38 Nicola Bowery

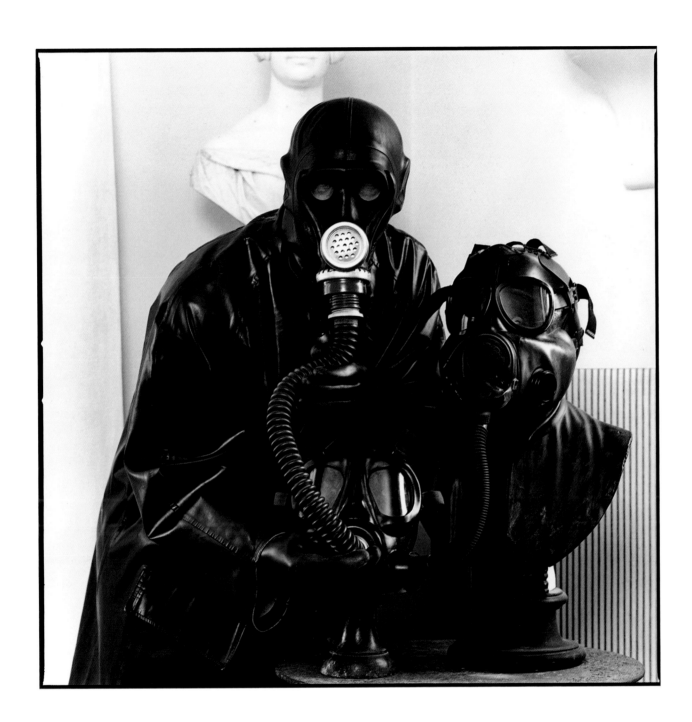

39 Mike with CR10 and E17

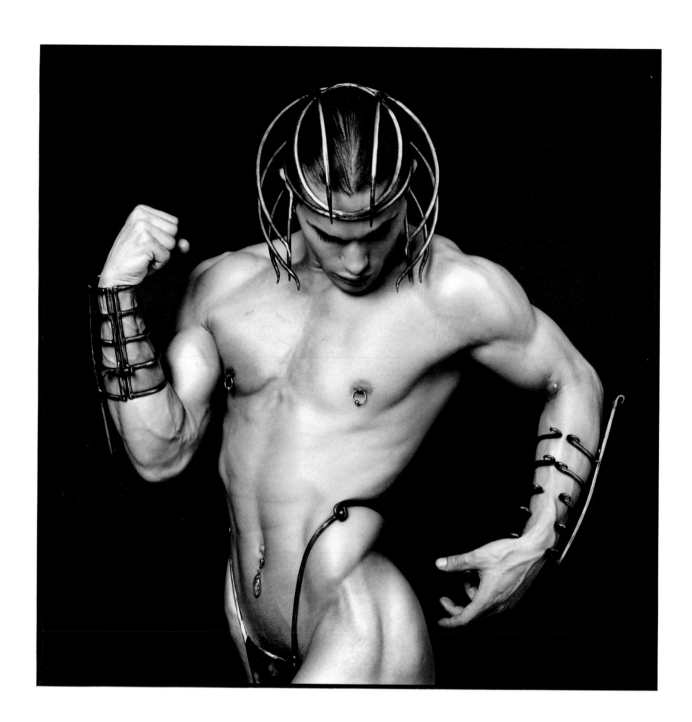

40 Enzo Junior

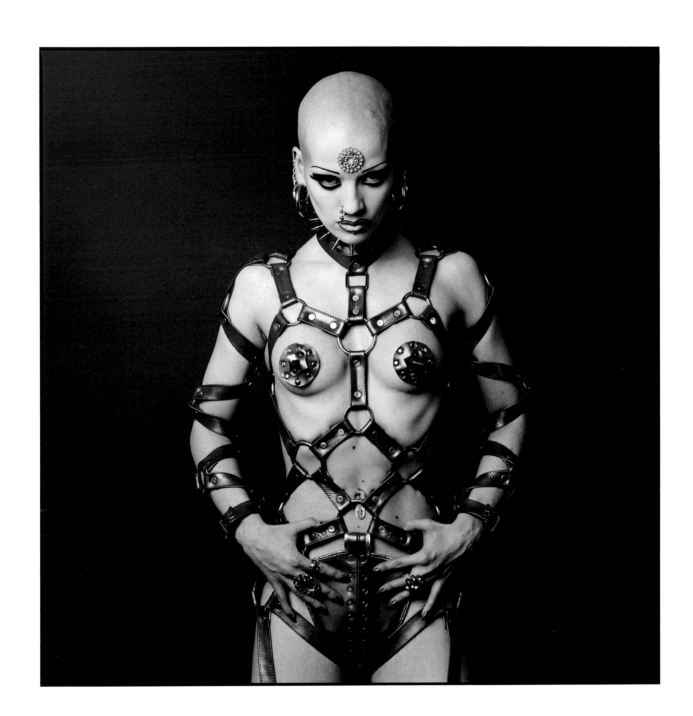

41 Polly

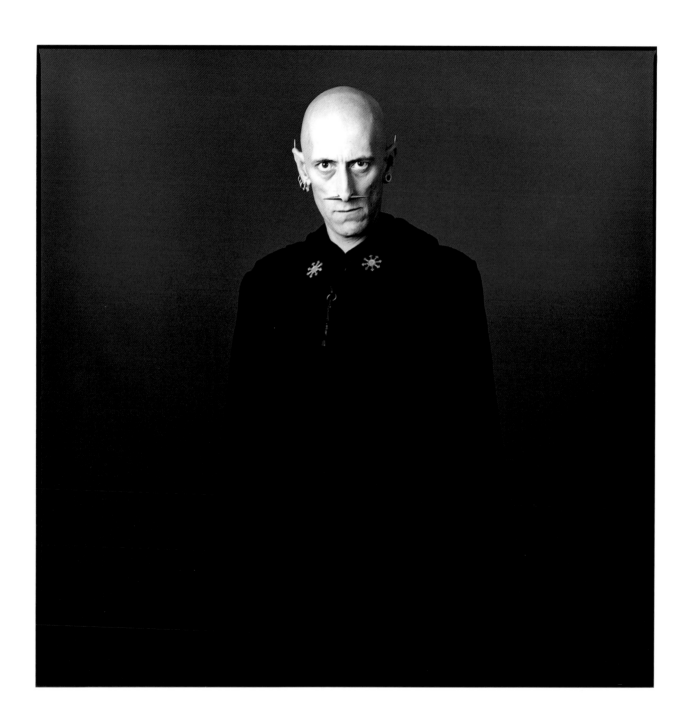

42 Peter Mastin

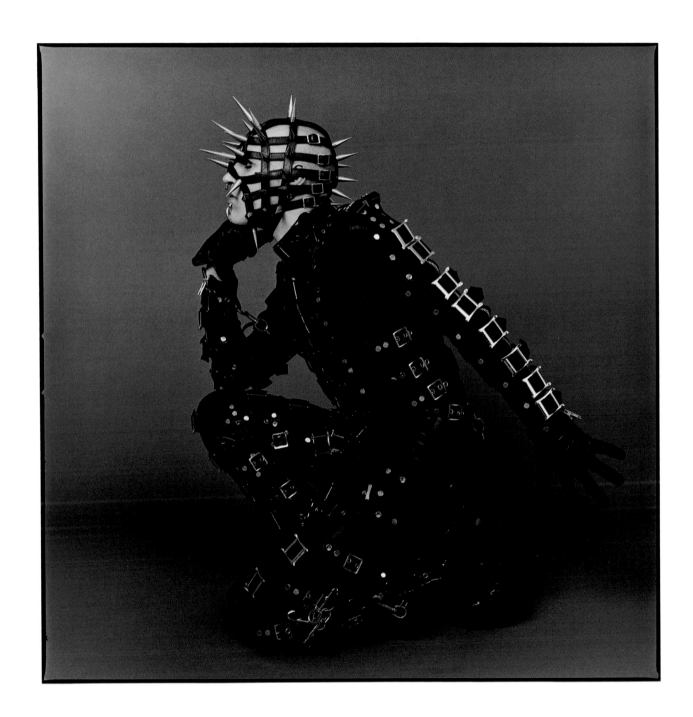

43 Nigel

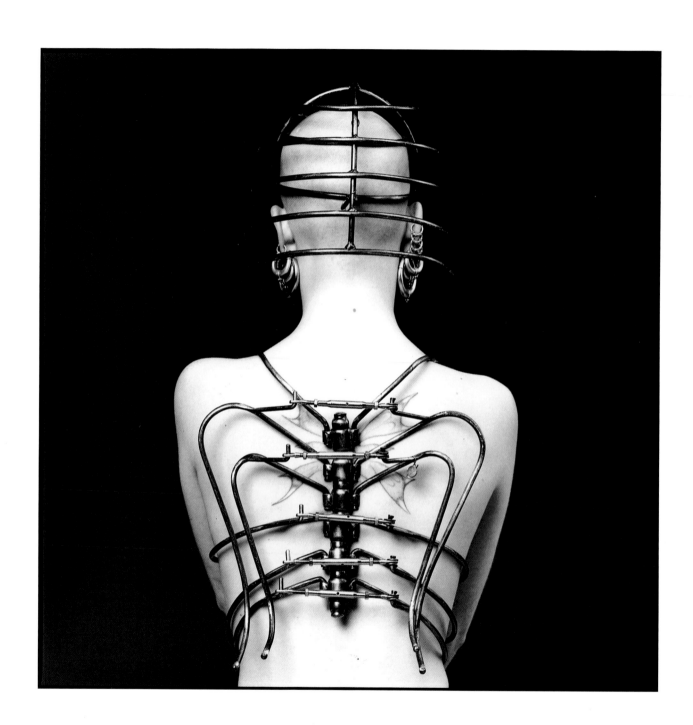

44 Polly

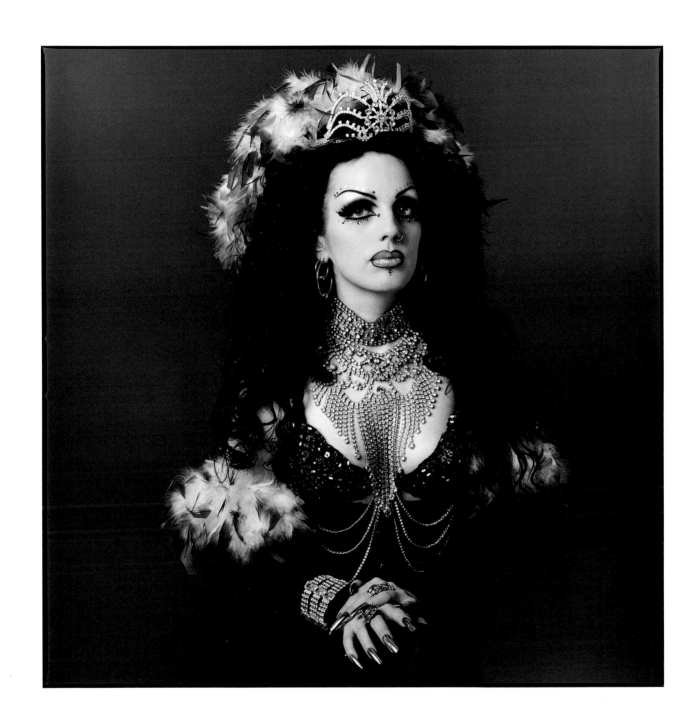

45 Suzy

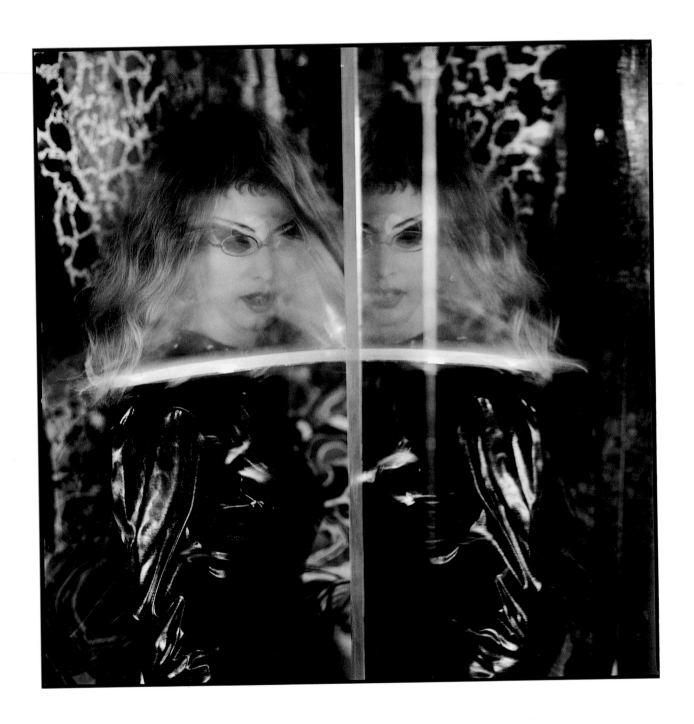

46 Nicola Bowery

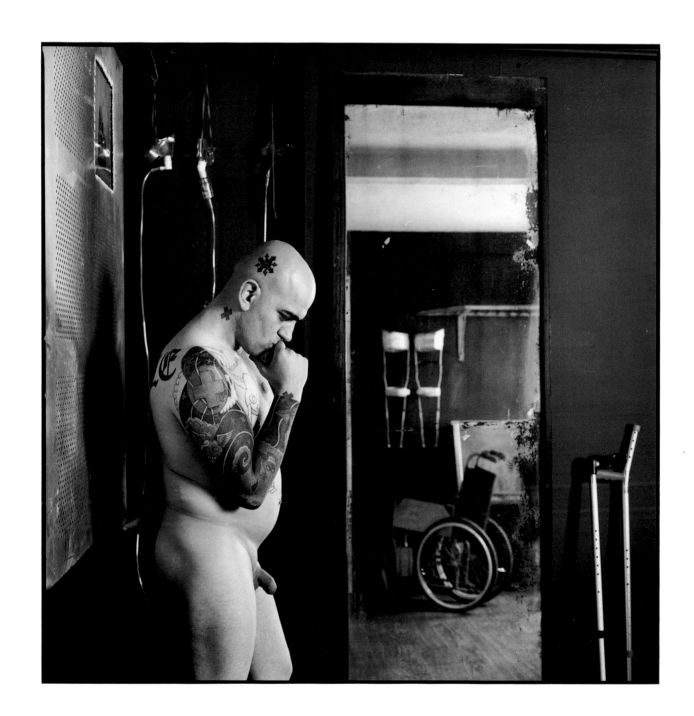

47 Franko B

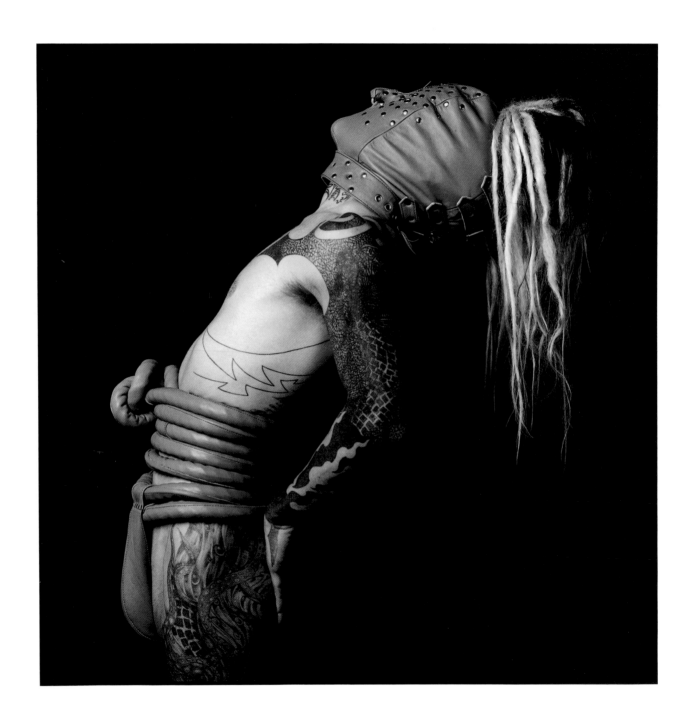

48 Xed Le Head

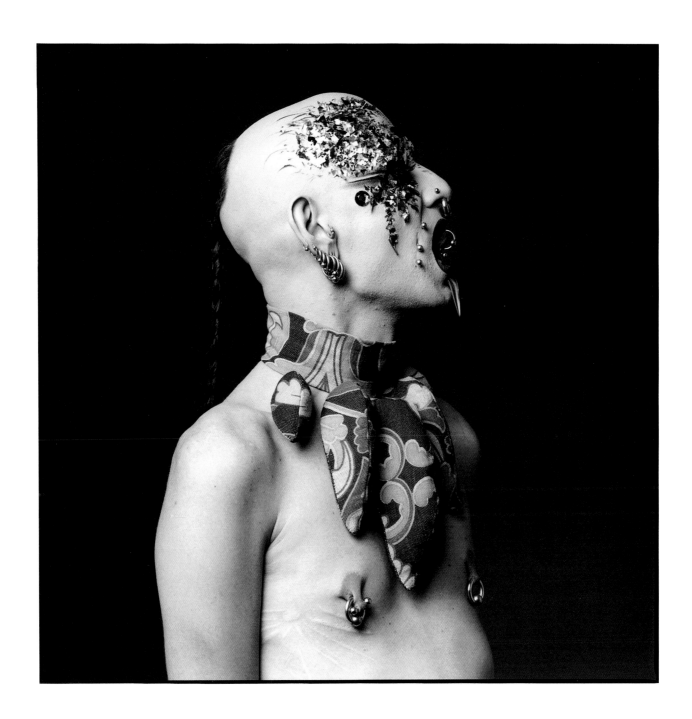

49 Fabian

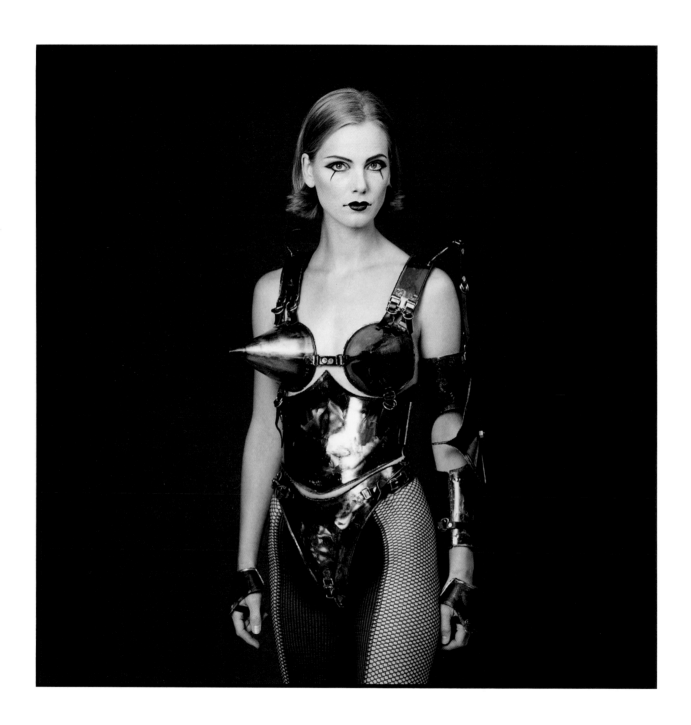

50 Fia Berggren

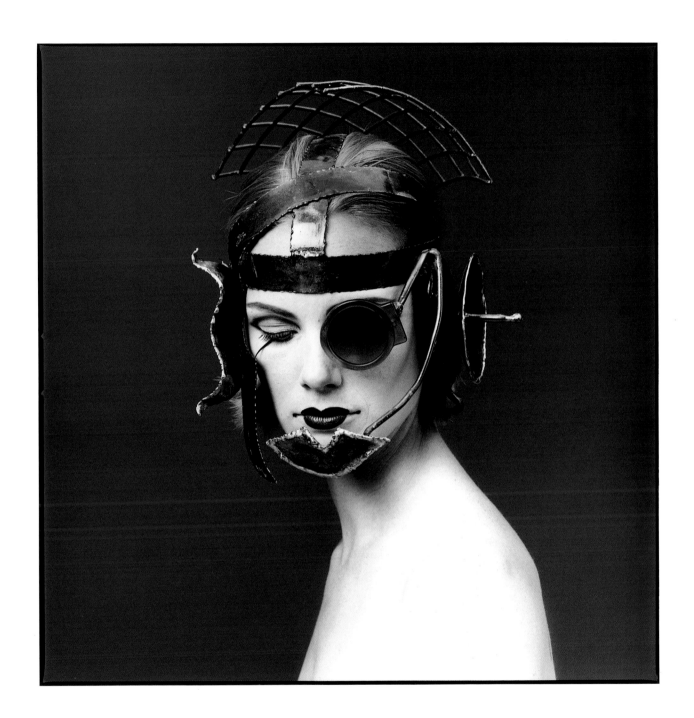

51 Fia Berggren

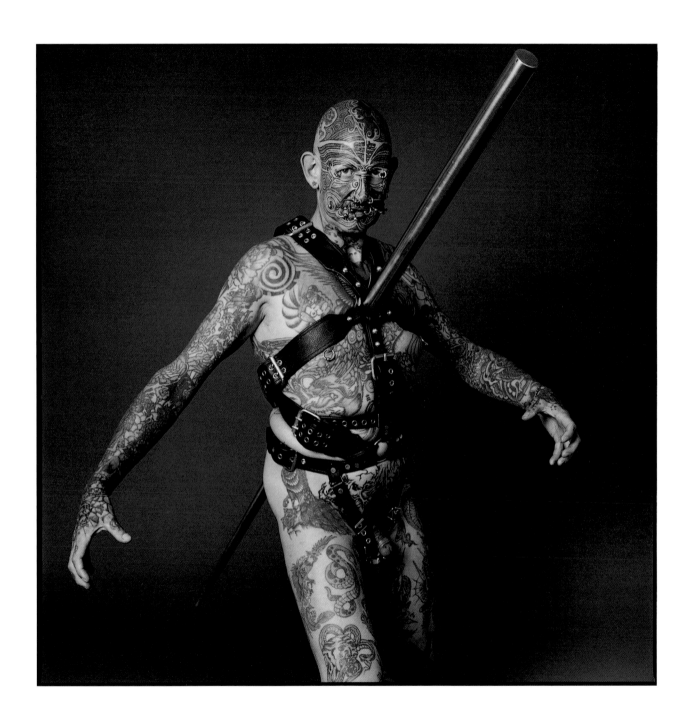

52 Dicky Dick

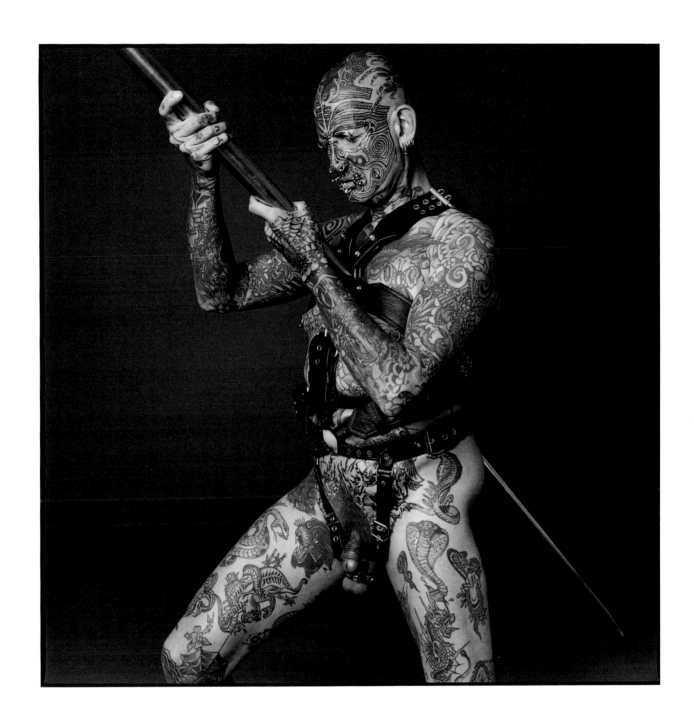

53 Dicky Dick

54 Scorpio

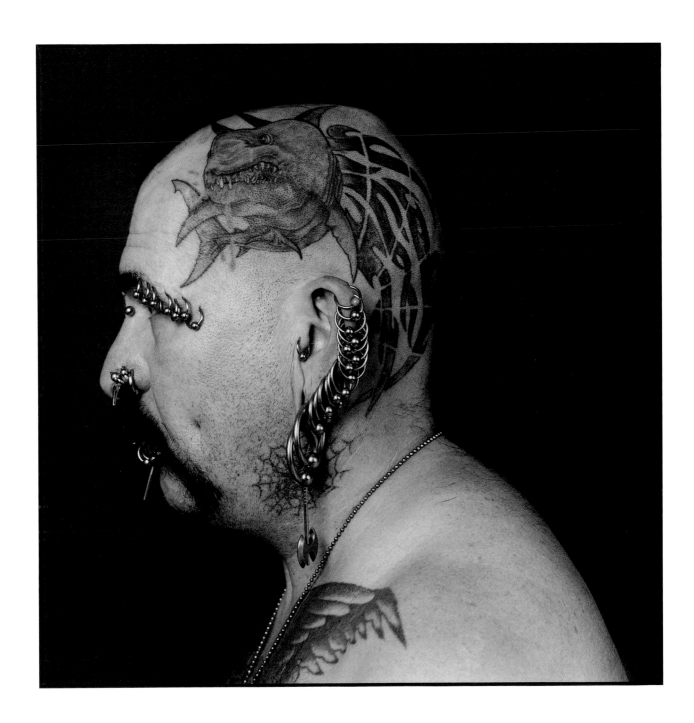

55 Alexandre Lambrechts

56 Suzy

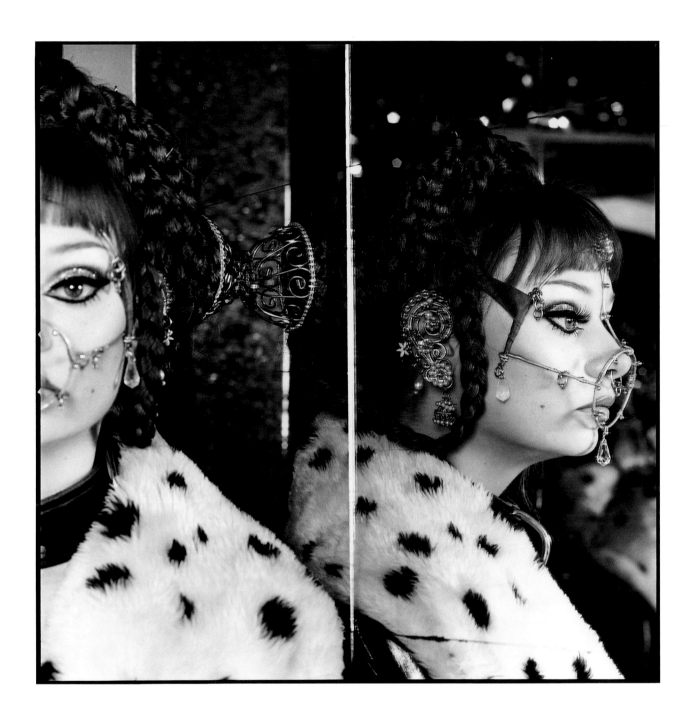

57 Christine Bateman

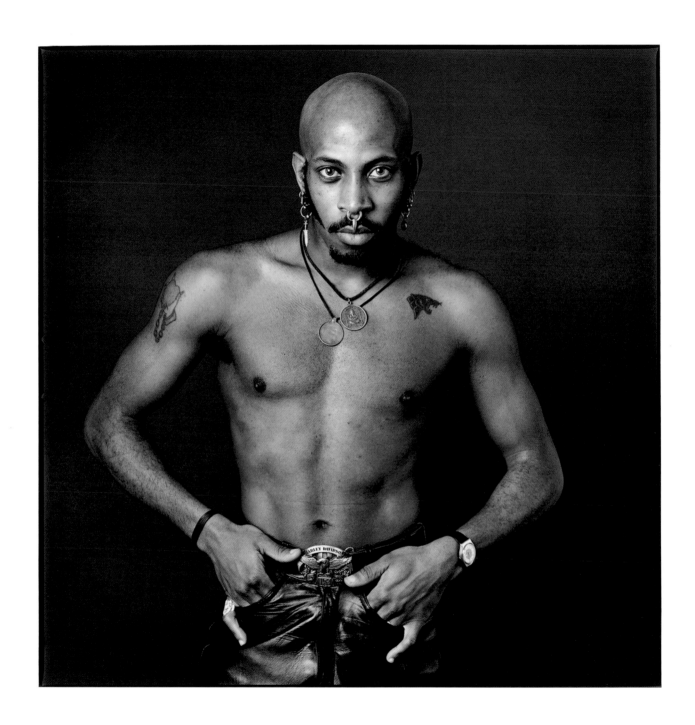

58 Ralph

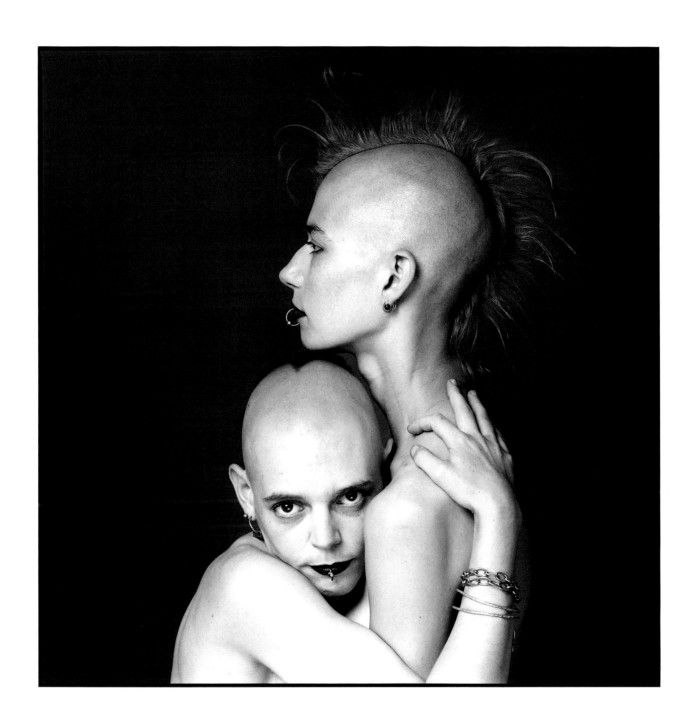

59 Jed Phoenix and Joss Munro

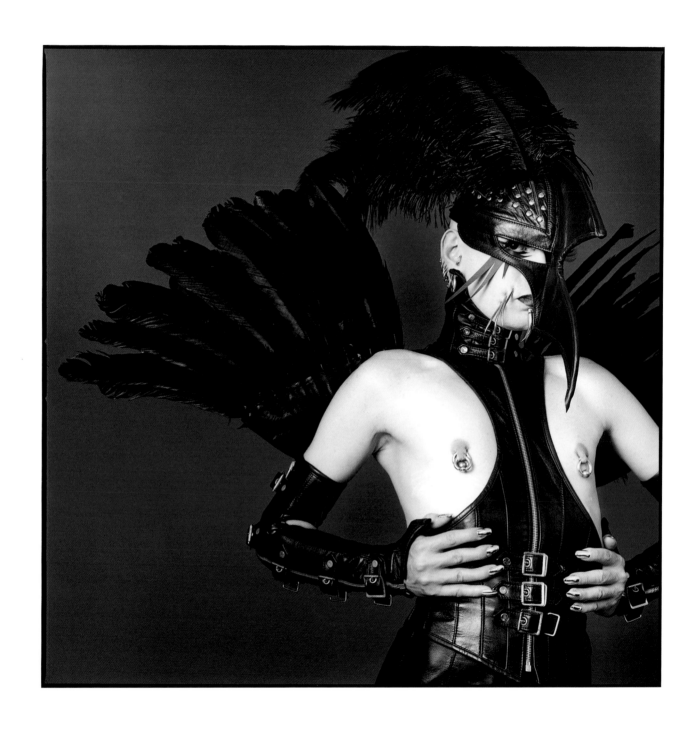

60 Fabian

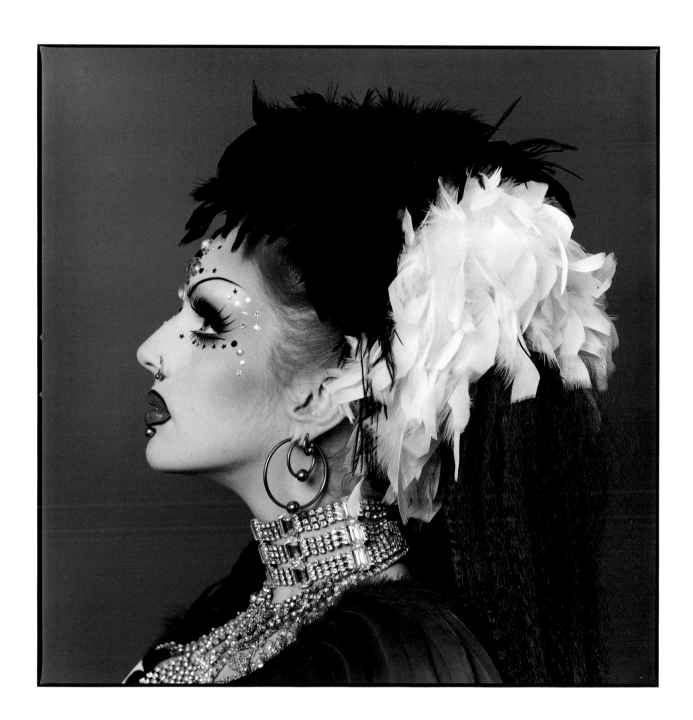

61 Suzy

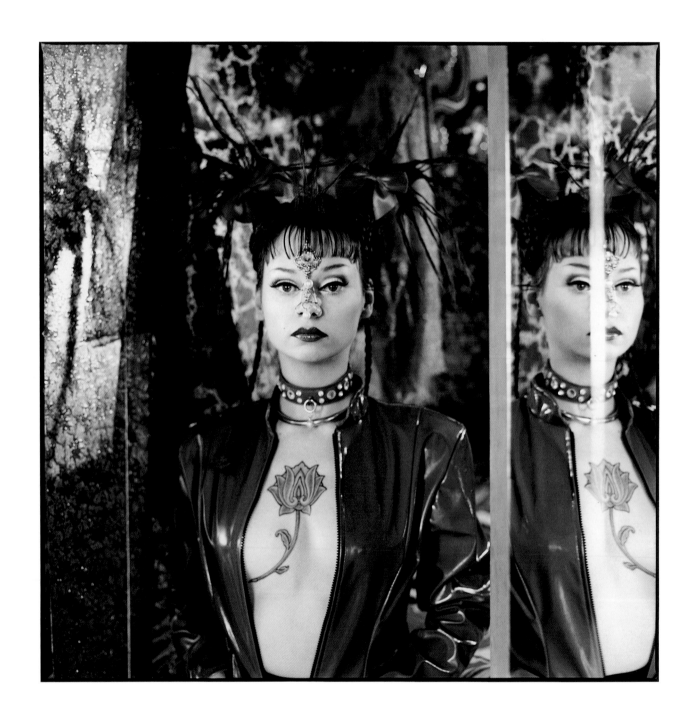

62 Christine Bateman

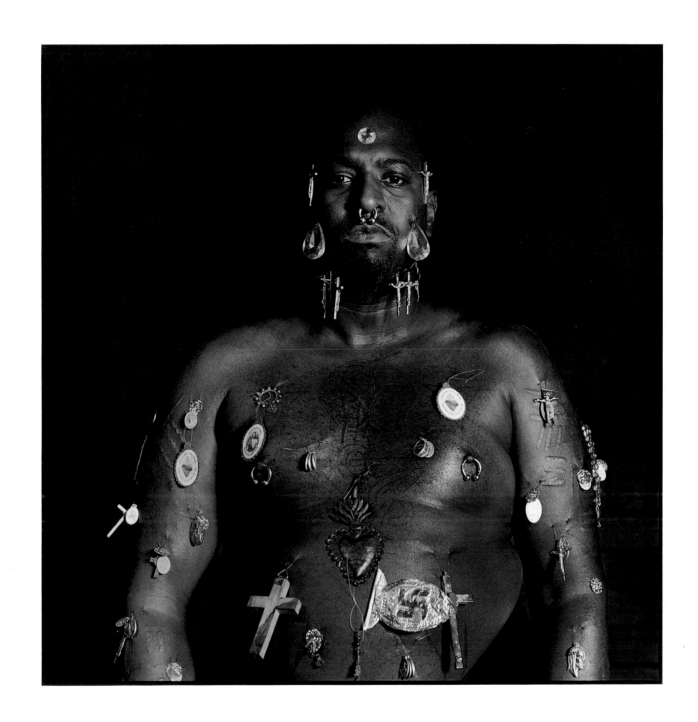

63 Darryl Carlton

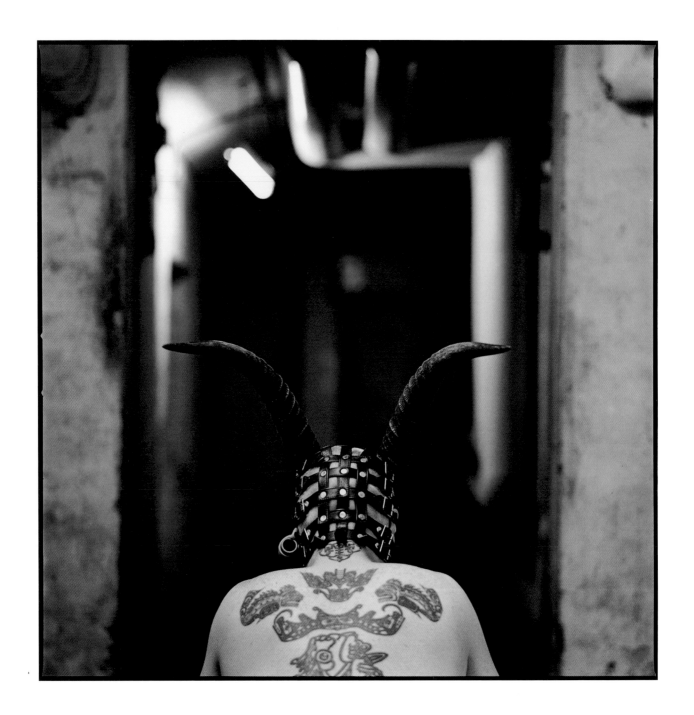

64 Lester

FETISHISM'S CULTURE Anthony Shelton

The limit and transgression depend on each other for whatever density of being they possess: a limit could not exist if it were absolutely uncrossable and, reciprocally, transgression would be pointless if it merely crossed a limit composed of illusions and shadows. But can the limit have a life of its own outside of the act that gloriously passes through it and negates it?[1]

MICHEL FOUCAULT

The poet W. B. Yeats wrote that 'only two topics can be of the least interest to a serious and studious mind – sex and death'. If we accept such singularity of vision (recalling that Freud shared a similar opinion that the eternal battle of Thanatos and Eros against society was responsible for the deep sexual anxieties that lie at the very heart of Western civilisation), it is difficult to escape or deny the morass of desire and disquiet in which our constricted sexuality has continued and continues to develop. Herbert Marcuse, the influential philosopher of the 1960s, goes further to describe the replacement of the libidinous pleasure principle by the constraints erected by society to guarantee its repressive order as 'the great traumatic event in the development of man'.[2] There is little that allows us to contest such a bleak view of contemporary sexuality which, according to one critic, '... has imploded and emits no radiance because it possesses no magic, no poetry, no charm, no veiled illusion, no sorcery, no secrets and no playfulness'.[3]

If the dryness of case histories, or their notable and intriguing absence in Freud's own writings on fetishism, deters one's investigative zeal, we need only look to the literature of the past one hundred years to persuade us of the pervasiveness of sexuality within our civilisation – the short stories of Arthur Schnitzler or the work of Emile Zola and Guy de Maupassant in the sexual turmoil of *fin-de-siècle* Vienna or Paris, and a spate of more recent writers – Henry Miller, Anaïs Nin, Anna Karan, Alberto Moravia, Georges Bataille, Jean Genet, Pauline Réage, André Pieyre de Mandiargues – to recall just a few. Sexuality, in the late twentieth century, infuses every aspect of our lives and the way we view and understand the world.

Georges Bataille agreed on the sharp distinction between functional sexuality singularly oriented to procreation and a second form of sexual behaviour – 'eroticism' – closely connected to ecstasy and even death, so often denied or misunderstood in Western society.

The essence of man as given in sexuality – which is his origin and beginning – poses a problem for him that has no other outcome but wild turmoil. This turmoil is given in the 'little death'. How can I fully live the 'little death' if not as a foretaste of the final death?[4]

Our reality admits desire solely after it has been ordered, domesticated and subordinated to the necessities of procreation, leaving only imperceptible and tabooed vestiges of the socially unacceptable sexual behaviour that it carefully circumscribes to oppose, forbid and denigrate, while all the time more clearly defining its own boundaries, prescriptions and sanctions. Eroticism is left a precarious existence on the margins of ethical social propriety where it is always viewed as possessing a potentially chaotic and menacing nature: a malign if not monstrous power, both transgressive and destructive, which we paradoxically try to deny or hide and sometimes embrace at the same time.

Fetishism, in the late twentieth century, has become the principal expression of eroticism, stimulating sexual imagination, creating new sensibilities and ethics, developing an iconography of desire and inventing a theatre of rebellious love which threatens to rekindle eroticism in a world which believed it to have been domesticated or banished. Fetishism, as the rich imagery captured by Nicholas Sinclair's photographs illustrates, and as this essay attempts to map, crosses many boundaries; it draws its 'perverse' imageries from an established, though often marginalised literature, art and philosophy, while sharing similar political ground, and occasionally, though importantly, similar strategies and tactics with some of the most important radical art movements of this century. Fetishism is far from a superficial passing fad or fashion. As a movement, it possesses its own strangely haunting and compulsive philosophy replete with a metaphysic, ethic and aesthetic that can only be understood in terms of a whole constellation of historical movements and sensitivities which we have here referred to as fetishism's culture.

'Wild turmoil'

Michel Foucault has described the dramatic transformations that occurred in the Western world view at the end of the eighteenth century when a society based on faith in essential truths and hidden essences embraced new perceptual frameworks which established the individual subjectivity of the body. The definition of the body on the one hand as a machine and on the other as a species or generic body based on biological processes[5] created the conditions for the emergence of new discourses on its personal and institutional care, normative social condition and medical regulation. From the end of the seventeenth century to the beginning of the twentieth century, discourses on the body's sexuality multiplied. The new disciplines of demography, eugenics, sexology, psychiatry and psychoanalysis emerged to guide and provide a set of values on positive sexual behaviour geared to procreation regulated within the domestic family.[6]

The idealised Victorian family, based on strong patriarchal ascendancy over the roles and relations between its members, also provided a model for British colonial relationships.[7] As at home, where the sexual desires of British women were denied expression in favour of their performing a slavish duty to procreation, so too the bodies of colonised women abroad were bound to the obligations associated with upholding the colonial order. Missionaries propagated the idea of the nuclear family and a division of domestic labour based on the European model. Their teachings carried a strong ethical interdiction which sought to prescribe and limit sexual expression to the family unit. Christianity provided a framework through which to project a transcendental ethics that linked the condition of women as economically and culturally colonised subjects to their domestic patriarchs at home with the politically colonised women of the colonies.[8] Not only positive sexual prescriptions united the women of different continents, but they were also the victims of shared criteria that made all non-conformists into their negative opposites. When European men looked for visible, inevitably anatomical, evidence that could be used to explain non-functional or erotic sexuality, it was first diagnosed in the women of Africa before being sought on the bodies of prostitutes and other metropolitan women whose sexuality remained unconstrained by family bonds.

The etiology of sexual excess was provided by the Hottentot woman, Saartjie Baartman. Exhibited in 1810, her supposedly exaggerated clitoris, the so-called 'Hottentot apron', provided the external evidence for the pathologisation of erotic sexuality.[9] Cuvier's notorious declaration that the size of the clitoris bore an affinity to that of the highest of the apes at one and the same time placed Hottentot women at the lowest level of the evolutionary scale while legitimising and providing supposed 'empirical' criteria for the affirmation of Europe's perennial fear of racial degeneration.

From this time onward, promiscuous European women were ostracised not only for their questionable ethics, but also for their 'demonstrable' evolutionary degeneration which threatened to consign them to a primitive and remote stage of human evolution, categorising them alongside 'savages'. At home, female eroticism was marginalised by its association with a lower and inferior stage of human development represented abroad. The male European gaze therefore eroticised, though in different ways, non-European women, who became the subject of repulsion and fantasy, denigration and desire, charity and possession.[10] Their excessive sexuality was a recurrent theme in travel writing, they appeared in literature as lascivious, while their presence in nineteenth-century painting – recall the role of the black maid in Manet's *Olympia* or the embracing black and white women in Jean-Léon Gérôme's *The Great Bath at Bursa* – provided a convention to express sexual eroticism. Not even the supposedly sober and objective gaze of anthropologists has been able

to eschew the eroticisation of foreign women, as is clearly evidenced in the confessionals contained in the diaries of two of its leading European exponents, Bronislav Malinowski and Michel Leiris.[11]

Eroticism and fetishism at one time belonged to two mutually distinct and separate discourses. Eroticism, as defined in the Oxford English Dictionary, clearly refers to sexual love, 'of or pertaining to the sexual passion'. Fetishism, on the other hand, was first used by sixteenth- and seventeenth-century Portuguese seafarers to refer to charms and amulets (*feitiço*), also to *hechizos*, witches, and in the nineteenth century to the idols and any other instruments related to African religious practices.[12] The fetish, again in the Oxford English Dictionary, is clearly localised: 'Any object used by the Negroes of the Guinea coast and neighbourhood as an amulet or means of enchantment, or regarded by them with dread', but the change in usage that occurred in 1837 gives the term a more general currency: 'something irrationally reverenced'. In addition, the dictionary defines the verb 'to fetishise' as 'to provide or adorn, to dress up'. In European eyes, African 'fetishes' were bizarre and irrational but nevertheless fascinating objects. Leiris's description of their abject and curious powers is typical of many late nineteenth- and early twentieth-century accounts. Describing a 'fetish' which is the object of a blood offering made in the village of Nkourala, he notes:

> *It is an amorphous mass which, as the four men lift it with great care from its niche, turns out to be a sack of coarse, patched canvas, covered with a sort of pitch made of congealed blood, stuffed with what one guesses to be an assortment of dusty things, with a protuberance at one end and a small bell at the other.*[13]

Despite the object's cultural distance and unfamiliarity, Leiris is nevertheless able to recognise its great religious significance.

The association between religious heresy and women was already present in the seventeenth-century Portuguese usage, but it was not until the nineteenth century that female believers and practitioners of African religion became generally known as '*féticheuses*'. Erotic forms of sexuality and paganism were joined in a discourse that saw both as usually contiguous criteria in the definition of those primitive and inferior conditions of existence distantly removed from the idealised lives of nineteenth- and early twentieth-century Europe.

Two views of fetishism persisted into the twentieth century. The one popularised by the colonial subjection of foreign peoples, which conflated eroticism as the lowest form of sexuality with fetishism as the lowest stage of religion, maintained its hold over much of Europe well into the mid-century. This view became if anything strengthened by the

interest of nineteenth-century psychiatry in fetishism as a pathological condition found also in the West. Just as native Africans were said to be subject to the delusion that the material form of an idol or the inanimate material that constituted a charm could have any efficacious power over the world, psychiatry characterised the fetishist as a person suffering a similar delusion which caused him to substitute a non-sexual object in the place of the sex organs as the focus of desire. Faulty logic was believed to lie at the bottom of both mis-identifications.

The second view of fetishism, while agreeing on its applicability to both African and European civilisations, did not see it as a sign of racial degeneration but as an aspect of humanity's universal unconscious, more in evidence in Africa only because it had become repressed and subordinated to a constrictive rationalism in the West.

The first of these views was represented in the international exhibitions which provided windows onto the 'primitive' conditions of colonised peoples. The French *Colonial Exhibition* of 1931, however, was notable because of the sharp response and counter-exhibition, *La Vérité sur les Colonies*, which it provoked from the Surrealists and the Communist Party. Although the Surrealists included Catholic images under the label *'Fétiches Européens'* to establish a shared proclivity between the African and European mind, their overall reaction to fetishism was ambivalent:

> *Fetishism is in effect pressed into service in different ways by Surrealism, the very ambivalence of the term, occupying a kind of terrain vague between public and private spaces, dream and waking, the interior and the exterior, Europe and its others, matching Surrealism's own situation.*[14]

Whether it was political reticence alone which made the Surrealists wary of embracing fetishism as part of their own project 'to change the hierarchies of the values of the real'[15] is difficult to know. Despite the ambivalence towards the category, however, their overall world-view suggests they verged on accepting it as a positive unconscious attribute of the mind.

This ambiguity was more generally and clearly reflected in early twentieth-century French attitudes to Africa. The two views of Africa presented by the French press were ambiguous as to who had the monopoly over barbaric acts.[16] The one, centred on the French possessions of Benin (then Dahomey) and Togo, affirmed Africa's dark heart stirred only by sexual promiscuity, pagan religion and cannibal ritual. The second focused on reports of the slave trade and European atrocities committed against the inhabitants of the Belgian Congo. Like the official view of Africa displayed by the colonial exhibitions and contested by the

Surrealists and Communists, newspaper reports swung uneasily between affirmations of African barbarism and the prospect of European degeneration into a similar condition. It appears, therefore, that the older framework juxtaposing African savagery and European civilisation began to lose currency during the inter-war years. No longer was it so easy to contrast two distinct mentalities, each belonging to a different time and space, ranked in a mutually dependent relationship of superior to inferior. The indices of barbarism were, as demonstrated by the senseless slaughter and destruction of the First World War,[17] also present in the European mind and could be seen as either the negative irrational side of human nature which, for the general good must be repressed and denied, or as a more natural and spontaneous dimension of human activity which promised the freedom and happiness that reason had kept imprisoned and silent.

The 'terrain vague' that fetishism had begun to occupy by the 1930s provided it with an indeterminate space which allowed its reinvention as an anti-bourgeois discourse of liberation. The dissident Surrealists Michel Leiris and Georges Bataille (although the latter avoided the use of 'fetish'), were central to the construction of this revisionist view of fetishism now closely associated with eroticism. In *The Sacred in Everyday Life* (1938), Leiris extols his theory of the personal nature of the concept of the sacred whose origin he finds in childhood memories. The presence of the sacred is conjured up by objects, places or occasions that provoke simultaneous feelings of fear and attachment, that are 'attractive and dangerous, prestigious and outcast – that combination of respect, desire, and terror that we take as the psychological sign of the sacred'.[18] The concept of the sacred may then grow alongside what others have identified as pathological fetishism. Leiris also includes in his article brothels as sacred spaces, on the basis of their separation from the ordinary world,[19] and, in an earlier draft (omitted from the published version), he lists the 'spells of Abyssinian sorcerers'.[20] Such manifestations, brothels, sorcery and his earlier recognition of the sacred nature of the Nkourala 'fetish', taken together, suggest not only that the sacred can assume a universal, as well as personal recognisable form, but that the sacred and the fetish have their roots in one and the same thing.

Eroticism also plays a similar and essential role in Bataille's understanding of religious experience. In *The Tears of Eros* (1961), Bataille argues that the experience of ecstatic sexuality preceded knowledge of the causal relationship between sex and procreation. The Palaeolithic cave paintings at Lascaux provided him early evidence of the association of sex with death. The remote stirrings of religious ritual were therefore performed to conquer the discontinuous nature of humanity by providing sacrifice as a means to affirm its continuity. For Bataille it is humanity's perception of itself as made up of discontinuous human beings who are doomed to perish that impels it to formulate means of becoming immortal. In

religious eroticism, therefore, it is sacrifice that embraces death and:

> *Erotic activity, by dissolving the separate beings that participate in it, reveals their fundamental continuity, like the waves of a stormy sea. In sacrifice the victim is divested not only of clothes but of life (or is destroyed in some way if it is an inanimate object). The victim dies and the spectators share in what his death reveals.*[21]

There are other writers in whom one can trace the fusion of eroticism with religion, and, therefore, fetishism itself, long held to be a rudimentary form of religious experience. I have chosen to discuss this theme using the works of Bataille and Leiris not because of their historical primacy but because of their shared anthropological and aesthetic concerns, which so closely conflate what had previously been divided in discrete spaces that opposed the distant geographies and histories of the colonies to the interior hearths of European civilisation. The religious dimension, with its focus on the dissolution of individuality, the transcendence of discontinuity, whether through a transgressive act such as sacrifice or direct sexual union, in the case of Bataille, or through the use of a technology such as masks[22] or trance, in the case of Leiris, anticipates the ritualisation and transgressive protocols of erotic sexuality and its association with ritual and the nether-world in performance art and fetish culture.[23]

Among the precursors of this culture of reverie should be included Pierre Molinier,[24] another dissident Surrealist whose unremittingly transgressive life-style caused even the Surrealists to reject him from their élite circles. It was not Molinier's early paintings – despite their conflation of eroticism and religion – that gave him importance, with their themes from ancient Egyptian and Indian religions mixed with sexually ambiguous, multi-limbed females, but his later work, including his *Cent Photographes Erotiques*. Here he used photography to explore his own sexual identity by assuming the role of transvestite dominatrix or submissive, sometimes performing self-fellatio or auto-sodomisation with his ingeniously made stocks and dildos, sometimes alone, sometimes with models, or with mannequins. Sharing the same project as other members of the Surrealist circle, his work, like that of the 1960s performance artists belonging to the Wiener Aktionismus group, was meant to provoke a catharsis in his bourgeois audience, to challenge their concepts of sexuality and morality, to 'contaminate' them and evoke what he believed to be a pre-Renaissance condition when religious rituals and sexuality were closely linked.

The intellectual and artistic terrain explored by Bataille, Leiris and Molinier, through which eroticism, ritual and religion intersected, may not have directly encouraged the growth of fetishised sexuality in the 1980s, but it undoubtedly helped to create the

intellectual terrain which has encouraged it to flourish. Writers, including the Surrealists, were more often influenced by perverse practices previously documented by others such as the Marquis de Sade or Gilles de Rais. In the main, the Surrealists were writers and theorists, not practitioners. One reviewer noted that what Dalí and other Surrealists dreamt of, Molinier did; and Breton's acute discomfort with some of the abject exhortations of Bataille is well known.

The emergence of fetishism as a deep and expressive form of eroticism has been attributed various causes in Europe,[25] but it best expresses a revolt against the immoderate ordering and policing of normative life. It holds an excess of meanings and associations that burst out of social classifications and ooze from the seams of socially sanctioned mores and norms; in the case of SM fetishism, what Foucault described as '... unreason transformed into delirium of the heart'.[26] It is a staging of state power relations 'played backwards', not for their repressive intentions, but for a theatre which refuses their legitimacy and transforms them into the means for creating pleasure and ecstasy.[27] It is the staging of fetishism that, by inverting the iconography and techniques of state power and repression, turns repressive imagery and technology into romanticised and highly sexually charged drama that confronts the state with its own nemesis.

A fascination with the ritualisation of sexuality and perversity is not new. Interest in, for example, corsets, high heels, rubber clothing and other bondage 'fashions', as well as body piercing, had existed at least from the nineteenth century, as can clearly be seen in the advertisements and letter pages of magazines like *London Life*, while SM fetishism has been dated to the end of the eighteenth century by Foucault, who saw it as 'one of the great conversions of Western imagination'.[28] Others have interpreted male fetishistic fixations as stemming from their renunciation of flamboyant dress styles at the end of the eighteenth century, when men displaced their gaze on female attire.[29] Nevertheless, lacking any formal organisation, such practices were not formally ritualised and were mainly pursued privately.

Four periods in the emergence and development of fetish culture within the twentieth century can be distinguished. The first, a period of relative liberalism, stretches from the century's beginning to the 1940s; a second is limited to the 1940s–1950s when the movement became more clandestine as a result of censorship and legal pressures; the third period extends from the 1950s to 1983, when fetish clothing began to enter the mainstream fashion world and fetishised images became more widely circulated through television and the media; and the final period is from 1983 to the present, when the movement emerged into a diverse but well-organised and sophisticated culture with its own political agenda, ethics, life-style convictions and clearly identifiable communities.

Until the 1980s, fetishism was a minority culture and the few clubs or private groups

that existed had limited and stringently monitored membership rules. Early societies like the Lotus Society, dedicated to foot fetishism, or the Mackintosh Society for rubber devotees in Britain, and the Old Guard in the USA, had narrowly defined interests and sometimes strict membership requirements that guaranteed their exclusivity. The Old Guard, an SM gay leather club that grew up during and after the Second World War, took its values from military disciplinary codes with their strict hierarchical orders, elaborate codes of conduct and behaviour and oaths of secrecy, and required long periods of apprenticeship before admitting new members as dominants (tops).[30]

By the 1960s, it has been estimated that there were eight small companies in Britain, with a few others in America and Germany, supplying the whole fetish scene with rubber clothing and equipment.[31] What appears to have been the largest of these companies, based in Germany, had a circulation list for its catalogues of 15,000, while another, in England, boasted a more humble 850.[32] Although production may not give an accurate view of consumer interest in fetishism, it provides one of the few general indications of the size of the scene at that time. With the first Rubber Ball in 1978 at the Hammersmith Palais and the emergence of a club culture, beginning in 1983 with the opening of Skin Two and Der Putsch in London; and encouraged by the work of fashion designers and advertising agencies, fetish culture quickly flourished and underwent rapid commercialisation, losing much of its former exclusivity and providing a venue for the fashion-conscious, as well as committed fetishists. In 1994, in Britain alone, there were forty-four different mail order catalogues advertising fetish clothing.[33]

Since the beginning of the 1990s there has been an increasing internationalisation of fetish culture, with magazines such as *Skin Two*, *Ritual* and the now defunct *'O'* containing regular listings of principal clubs and events in New York, Chicago, London, Amsterdam, Berlin and Paris. This internationalism is also reflected in the clientèle of the more established of these clubs in London, Amsterdam or Cologne who tend to be drawn from across the continent. The culture has also been popularised by its association with popular musicians such as Soft Cell and Siouxsie and the Banshees, opera stars like Lesley Barrett, and other celebrities who include Jean Paul Gaultier, Madonna and Leigh Bowery.[34]

Even before the Scene became successful, events like Tuppy Owens's annual Sex Maniacs Ball (now the Safer Planet Sex Ball) brought together part of the fetish crowd. These, together with similar events such as the Rubber Ball and Ball Bizarre, encouraged the emergence of a US culture with equivalent events like the The Dressed to Thrill Ball. The touring *smutfest*, growing out of the politicised sex/art cabaret begun by Annie Sprinkle and Jennifer Blowdryer in a New York strip bar in the mid-1980s, also provided a fertile and vibrant meeting ground to further political awareness of sexual issues, censorship and

repressive legislation.[35] While the culture of fetishism may not be as developed in America as it is in Europe, New York can still boast a dynamic scene with clubs like The Vault, House of Domination, Paddles and Fetish Factor, with smaller club scenes in Los Angeles and San Francisco.

Staging sex

Contemporary fetishism draws its inspiration from a baroque repertoire of fantasies, theatrical images and literary associations which feed on allusions to power, authority, decadence and transgression. Gothic romanticism sometimes provides the staging for events, blacked-out spaces, the dungeon area, candlelight and, in one case, the sound of opera straining against shrouds of muslin hanging waspishly from high ceilings. Their atmosphere is not so much threatening as dream-like,[36] a space torn away from the conventions of the everyday, which nevertheless suggests the arrested expectation of realising repressed desires. The decoration, the technology of torture, the harsh veiled costumes of the black phantoms that haunt these spaces, as in the theatre, aim to encourage the suspension of belief and even the memory of the prosaic world which at most other times surrounds their initiates. History is repressed, time is denied, present blistering social conditions are forgotten in a revelry totally out of time, out of place in a society ordered by rational discipline and technological faith.

Fetishism has no manifesto. Its diverse strands are loosely brought together by shared issues in sexual politics, radical though diverse sexual practices, shared clubs (The Torture Garden, Der Putsch, Whiplash, Kinky Gerlinky, Submission, Pagan Metal, Fist) and magazines *(Fetish Times, Ritual, Skin Two, Zeitgeist, Cul d'Or, Splosh)*. It has its own literary genres that evoke rich connotative styles and descriptive practices that define devotional canons (de Sade, Sacher-Masoch, Mirbeau, Réage, de Berg), and clothing and decorative styles through which fantasies are robed and realised. The scene has uneven and imprecise margins which blend readily into other sexualities, while being dynamic and changing, adopting or generating new fashions, styles, practices and artistic and literary productions. Fetishism has also stimulated a growing business of fashion designers, stylists and crafts people, some of whom take their inspiration from the literature discussed in this section, to support and develop its extravagant visual culture.

Above all, fetishism is a highly structured and orchestrated sensual culture that blends together visual, tactile and olfactory stimuli. Far from substituting the reproductive sexual organs for surrogate objects, fetish culture creates total environments designed to elicit, extend and enhance sexuality out of its conventional narrowly defined and strictly policed

boundaries. Instead of being, as the mainstream press would have it, a dangerous unstructured transgression of codified normative behaviour, fetishism promotes its own rules, precautions and protocols that guide the relationships of its practitioners. These are frequently reiterated in articles in *Skin Two* or *Fetish Times*,[37] and are the subject of books such as Trevor Jacques's *On the Safe Edge: A Manual for SM Play*, or Pat Califia's *Sensuous Magic*.

Among the committed movements, litanies and canonical texts are works of the Marquis de Sade and Leopold von Sacher-Masoch as well as contemporary authors such as Lizbeth Dusseau, Maria del Rey, Titian Beresford, Paul Little and Alizarin Lake. These and other works serve as literal and poetical scripts helping to choreograph behaviour, establish scenography and evoke the frisson which culminates in the conjuring of desire and its release. Some of these texts have even provided the source from which manufacturers, such as those connected with the *Centurion's Whole Catalogue of the Exotic and Bizarre*, have designed and made entire wardrobes and sets of costumes and accoutrements to aid the realisation of particular scenes.

The more philosophical significance of such transgressive texts has been hinted at by Jean Paulhan. Writing on de Sade's *Justine*, Paulhan compares his work to the New Testament as bearing 'On every page, in every line ... something never flatly stated, but which intrigues and involves us all the more on that account.'[38] Simone de Beauvoir pinpoints more accurately the value of de Sade's work as a creation of a large philosophical apparatus, an alternative metaphysics, if you like, to justify the actions of his protagonists.[39] In de Sade, as well as Sacher-Masoch, Bataille, Mirbeau and de Berg, Western Christianity, with its related moral and ethical systems, becomes their principal adversary. Nevertheless, more often than not, such writers would like to commend an alternative, often secular, religion of sensuality. It is no accident that Sacher-Masoch's protagonist takes the name of Venus and that allusions to classical mythology and Nordic paganism abound throughout the text. Religious elements are also found in the allusions to vaults, cells and chapel-like rooms found throughout the works of Réage or de Berg, and in the ritualisation of behaviour codified by modern writers such as Terence Sellers in her *The Correct Sadist*, and in fetishistic cults such as *The Temple of Psychic Youth*, or occult or new-age groups centred on one or other form of the earthly goddess. De Sade's ability to disturb us and confront us with the need to rethink human relationships[40] gives central importance to his work for redefining sexuality as well as providing us with an encyclopaedia of perversions in the best eighteenth-century tradition.[41]

The status of these literary works also derives from them having preserved and passed down a canon of sexual practices which, although they may have first entered fetish culture

through magazine articles, short stories, editorials and derivative literatures,[42] have nevertheless exercised a strong and continuous influence on the subject and style of contemporary writers. They are what Jean Paulhan, in his introduction to *The Story of O*, rightly identifies as 'dangerous books', those that inform, instruct and reassure us, taking us back to confront our 'natural state of danger' from which we are no longer permitted to seek refuge.[43] Their instructional content is explicit. In the introduction to *Philosophy in the Bedroom*, de Sade exhorts his readers to emulate the actions of his characters:

> *Voluptuaries of all ages, of every sex, it is to you only that I offer this work; nourish yourself upon its principles: they favor your passions... Lewd women, let the voluptuous Saint-Ange be your model; after her example be heedless of all that contradicts pleasure's divine laws, by which all her life she was enchained... You young maidens, too long constrained by a fanciful Virtue's absurd and dangerous bonds and by those of a disgusting religion, imitate the fiery Eugénie... And you, amiable debauchees,... study the cynical Dolmance, proceed like him and go as far as he if you too would travel the length of those flowered ways your lechery prepares for you.*[44]

Terence Sellers's *The Correct Sadist*, like de Sade, Sacher-Masoch and Réage, intersects different genres bringing together philosophy, narrative and instruction, while likewise defining suitable structures to model transgressive experience, behaviour and aesthetics.

Many of these works describe, and sometimes define, the often exuberant decoration of the fetish world. It is opposed, often hidden, marginalised or liminal to the everyday world. 'The city is a map of the hierarchy of desire, from the valorised to the stigmatised',[45] according to Califia. The 'sex zones' are usually superimposed on another functional area to allow them to remain invisible until dusk, when under the canopy of night they assume the character many of its customers would ordinarily deny. Here, too, reality often mirrors literature in orchestrating the movement from the everyday to the fetishistic world as a type of *rite de passage* marked by the ritualisation of the stages of removal, liminality and re-incorporation.

In Mirbeau's *The Garden of Evil*, the path along which the narrator is drawn begins in a cultivated but exotic and exuberant garden; a paradisal world which provides a strange but recognisable norm. Then the narrator crosses the cultivated countryside separated by the 'black and pestilential waters'[46] of a river before descending into a liminal nightmare world of putrefying smells, filth and squalid buildings:

The quayside disgusted me. It was filthy and full of potholes, covered with black dust and strewn with fish entrails. Stinking odours, the sound of brawls, the shrilling of flutes and the barking of dogs could be heard from the depths of the hovels bordering it: verminous tea-houses, cut-throat shops and disreputable looking workshops... As we drew near, the smells became more unbearable, and filth thicker underfoot.' [47]

Past the carrion markets they walk until they finally arrive at the prison where the victims of the voyeuristic and sadistic Clare await their torture and degradation.

The path clearly leads from a world which, though unfamiliar and exotic, nevertheless has its own laws and codes of behaviour, crossing a marginal plain and finally entering a disorderly, apocalyptic world made up of a bestiary of jailers and tormentors and their desocialised, animal-like victims returned to a wretched state of savagery. The journey Clare and the narrator undertake is one from orderly civilisation, hemmed in by its laws and restrictions, to a bestial wilderness of fallen savages.

This transition from normal moral space to its opposite is also effected in Pauline Réage's *The Story of O*. After O has been picked up during her walk in the Monceau Park and delivered to what externally is a comfortable bourgeois house, 'the type of small private dwelling one finds along the Faubourg Saint-Germain', [48] she enters a world of moral privation. She is imprisoned in a cell-like vault. The interiors of the château reserved for masters and slaves offer extremes in sumptuous and spartan decoration; the book-clad library with its crackling fire that O remembers so well as the place where she was first 'interrogated', the small bedroom with mirrored walls where she waited after she had bathed herself and the cell which was to be her home.

The cell was quite small, and actually consisted of two rooms. With the hall door closed, they found themselves in an antechamber which opened into the cell proper; in this same wall, inside the room itself, was another door which opened into the bathroom. Opposite the doors there was the window. Against the left wall, between the doors and the window, stood the head of a large square bed, which was very low and covered with furs. There was no other furniture, no mirror. The walls were bright red, and the rug black. [49]

In Jean de Berg's *The Image*, the quarters in which Anne is made to serve her mistress and master are described in a detail that is meant to convey the same arrested moral equivocation:

The Gothic chamber was exactly as it had been in the photographs: the iron bed, the paving stones in a black and white checkerboard pattern, the two stone pillars which

supported a high vaulted ceiling above the narrow recessed window, covered now by red
velvet curtains… The whole thing, at once austere and intimate, reminded one vaguely of
a chapel.[50]

Sacher-Masoch's *Venus in Furs* also uses a gothic romantic style to conjure the atmosphere of the sexual 'other'. 'Venus must hide herself in a vast fur lest she catch cold in our abstract northern climate, in the icy realm of Christianity,' Severin says to Wanda.[51]

The interiors of the lodgings inhabited by Wanda in the Carpathians share a similar gothic style, large bare rooms, lit by blazing fires and sparsely furnished except for the ubiquitous ottoman and the copy of Titian's *Venus with the Mirror*. When Wanda and her entourage reach Tuscany, the interiors become more sumptuous, leaving Severin less comfortable in their surroundings.

I climbed the wide marble stairs, passed through the antechamber which is a large
extravagantly furnished drawing room, and knocked on the bedroom door. I knocked
softly, intimidated by the luxury displayed around me … The room was entirely
furnished in red, the carpet, the curtains, the hangings and the canopy above the bed.
A fine painting showing Samson and Delilah decorated the ceiling.[52]

The attention to detail is minute and exact. The interior and exterior spaces of this world mirror the ethical divisions between the repressed and everyday sensations of the ordinary world and the extraordinary supersensual lusts of the fetishist. The sexual 'other' is removed in space and time, perhaps even out of space and time, and constructed from the fragments remaining from the bourgeois rejection of baroque abandonment or gothic fantasy.

Literature also provides many of the ideal models on which fetishism styles its usual highly structured scenarios. Simple inversion and reversal provide one of the most often used, easily recognisable and effective means of staging moral and sexual distance. In the fantasies of *Nutrix* magazines, the world is often peopled only by women who subject each other to strenuous and sadistic treatments. It is pain that causes pleasure. Sexual teasing replaces male penetrative sexuality. When men do appear, they are the victims of women, tortured by female Nazi officers or usurped by secretaries who don leather and rubber outfits to overpower and feminise their bosses. Examples of these reversals abound in the works of recognised writers: the torments inflicted on Justine by Juliet, or by Eugénie with the incestuous Madame de Saint Ange and Le Chevalier on Madame de Mistival, her mother, recounted in de Sade's *Philosophy in the Bedroom*, Réage's description of the treatment of O by the club of Roissy, Clara who guides her shocked bourgeois lover through

a Chinese torture garden, the subjection of Anne by Claire and Jean in *The Image* or the roles assumed by Severin and Wanda (Gregor and Venus) in Sacher-Masoch's story of male submission.

The works discussed here form part of a corpus characterised, like those of the Surrealists previously discussed, by their opposition to bourgeois humanism and the values and life-styles they represent. These writers have sought to free the imagination from all moral strictures, laws and values which restrict its unfettered reign. Eugénie asks her debauched instructress '... by allowing this imagination to stray, by according it the freedom to overstep those ultimate boundaries religion, decency, humanness, virtue, in a word, all our pretended obligations would like to prescribe to it, is it not possible that the imagination's extravagances would be prodigious?'[53] This sustained attack on Christian morality, often in favour of a regression to a more primordial, immediate and instinctual condition or religious experience, is a recurring theme as much in the theoretical writings of Bataille as in literary work and radical sexual practices. Clara's dismissal of the West's restrictive morality in favour of the deeper primordial desires of nature is uncompromising:

> *There are no other limits to freedom than your own self ... no other limits to love than the triumphant variety of desire ... Europe and all its hypocritical and barbarous civilisation is a lie. What else do you do there except to lie, to lie to yourself and to others, to lie to everything which, in the depth of your hearts you know to be the truth? ... In this unbearable conflict you lose all your joy of life and all feeling of personality because at every minute the free play of your instincts is being constricted, impeded, stopped.*[54]

Not only do these literary works propose an alternative ethics of negation, but they offer an instruction guide towards the formulation of alternative relationships based on an aestheticisation of pleasure and pain.

The denial of bourgeois morality is also a central part of the sexual politics of the hard fetish culture. However, the alternative proposed by activists such as Pat Califia, Nicki Wolf and Tim Woodward, as with most of the protagonists of the culture, owes more to their almost unconditional support of consensual if radical sexualised life-styles rather than the anti-humanist philosophies and aggressive violative scenes taken from the pages of de Sade or Mirbeau.

Finally, whether it be the château in which O becomes prisoner, the Carpathian inns and Florentine loggia in which Wanda spins the destiny of her hapless slave, the Cantonese 'palace where everything is designed for a life of freedom and love, among marvellous

gardens',[55] or one of the better fetish clubs – The Torture Garden, Club Doma, Submission, Whiplash or Der Putsch – the scene provides a startlingly alternative world of staged danger which provokes foreboding and trepidation, which leads to a heavy reverie of sinking, suffocation and sometimes claustrophobia before its protagonists find themselves reborn into what Blanchot has charmingly but perceptively called a 'fairy-tale world'. The essential transforming dream-like qualities of these places are the subject of Miranda Raven's short narrative, 'My Crystal Chamber'.

> *This is the view at the door of my chamber, emerging from the world of solid things. There are no solid things within. It is the world of flux and change, an ideoplastic world, a looking glass world, the world behind the world.*[56]

The literary references, and there are a great many more than the few mentioned here, are reinforced and are given expanded circulation through films and related media based on or influenced by the transgressive worlds they evoke.

Legal sex films date only from the 1960s and began with Russ Meyer's *The Immoral Mr Teas*.[57] The use of violence to compensate for restrictions on sexual content gave rise to the sub-genre of the 'kinkie', producing such films as Joseph Mawra's *Olga's Girls*, *Olga's Massage Parlor* and *White Slaves of China Town*, and Bob Cresse's *Love Camp 7*, which pioneered Nazi imagery and influenced later films such as *The Night Porter* and *Salon Kitty*. Not until the early 1970s, influenced perhaps by Luis Buñuel's *Belle de Jour*, did producers begin adapting classic erotic literature for the cinema.[58] Redemption Video, perhaps the most prominent distributor of genre films targeted at the fetish market, have brought out Massimo Dallamano's *Venus in Furs*, Tinto Brass's *Salon Kitty* and Fritz Lang's *M*, as well as 'Sado-Vampiric classics' such as Jean Rollin's *Le Frisson des Vampires*, *La Vampire Nue* and *Requiem for a Vampire*, and Jess Franco's *Succubus*.

Other distributors, notably Skin Two and other stylists, disseminate powerful evocations of the culture through videos of fetish events and clothing fashions. Cleo Uebelmann, the director of *Mano Destra*, a cult bondage film, attributes the formation of her own awareness of fetish and SM imagery to art and advertising.[59] Jean Paul Gaultier was also brought to the imagery of fetish culture by the leather jackets worn by Marlon Brando and James Dean, as much as by the corsets and orthopaedic instruments discovered as a child in his grandmother's cupboards.[60] Other fashion designers have drawn heavily on certain fetishised images, although usually showing a preference for strong dominant archetypes such as the dominatrix rather than submissive and vulnerable roles like maids, nurses, adult babies and slaves. In addition, a prodigious visual imagery is distributed in comics and magazines

where the photographic styles of Irving Klaw, Helmut Newton, Bob Carlos Clarke, Eric Kroll, Doris Kloster, and Shinji Yamazaki have had a wide and enduring influence in creating not only the style but also the feeling of the haughty or enslaved woman temptress.

The relationship between fetishism and fashion is more than just a little problematic. Fashion has long been a convenient rubric for fetishism to express itself. From 1923 to 1940 *London Life*, one of the most important fetishist publications of the century, published extensive coverage of corsets and high heels and dealt with subjects such as transvestism, body piercing and corporal punishment.[61] John Willie, in the 1950s, subtitled *Bizaar 'a fashion fantasia'*, and during the 1960s *High Heels, Pussy Cat, Relate* and *Bizaar Life* also emphasised fashion and dress. The coverage of this theme has unsurprisingly continued to grow in contemporary magazines such as *Skin Two*, *'O'* (subtitled *Fashion, Fetish and Fantasies*), *Ritual* and *Zeitgeist*. Perhaps more surprisingly for the 1960s, hidden under the euphemism of slimwear, ski-clothes, skin-diving suits, riding macs and rubber sheeting, fetish clothing was already being widely advertised in the Sunday press, international news magazines and society magazines.[62] At the same time, images of rubberware were mass circulated through John Sutcliffe's tight-fitting rubber cat suits worn by Diana Rigg and Honor Blackman in the TV series *The Avengers*. Since this, film's flirtation with fetish material has been prodigious – Catwoman's rubber cat suit, or the black rubberised costume of Batman himself in Tim Burton's *The Return of Batman*, the dominatrix costume designed by Karl Lagerfeld for Barbet Schroder's *La Maîtresse* and the spiked headgear in Clive Barker's *Hellraiser*, to mention just a few.

Filmic images such as these have also directly influenced fetish culture, with many Catwoman look-alike costumes suddenly appearing in clubs after the film's release, or E. Garbs's adaptation of the Hellraiser image for his open-spiked helmet mask shown in Nicholas Sinclair's photograph of Nigel (23, 43). Clothing, and latterly fashion, is central not only in creating sexual attraction but in marking the distinct roles and giving the specific identities to the protagonists within a scenario. Because of their constraining qualities, stiletto heels and corsets have always been at the centre of fetish tastes, but the use of new materials such as rubber and PVC, and the creation of new styles, have enabled almost any traditional piece of clothing to be given a fetishised look. Influenced by mainstream subversive movements like Punk and Goth, and by its own parodying of the vampire-like *femme fatale* or of science fiction models to produce the cybersex look, fetishism provides a powerful statement against gendered or unisex fashions. Different materials have assumed fetishistic significance in different historical periods with the silk, fur and velvets much favoured by the Victorians being largely replaced today by leather and newer materials like

rubber and PVC. As early as 1970, rubber was seen by one writer to be the chief form of fetishism in the USA, UK and northern Europe.[63]

Different materials have particular associative meanings that stem either from deeply held psychological anxieties or archetypes or result from cultural codes. North finds that most rubber fetishists only secondarily accept leather and PVC when their properties resemble rubber[64] and that all three materials are closely associated with authoritarianism.[65] According to another writer, however, these materials are distinct. 'Leather is atavistic, pre-industrial, and romantic, rubber is futuristic, technological, and science fictional.'[66] Leather recalls something more primitive: the animals from which skins were taken, the masculine predator, the outlaw whose power grows and whose image becomes increasingly focused as society becomes more technological, more organised, homogeneous and ordered. There can be few more powerful and uncompromising expressions of this than in Nicholas Sinclair's portraits of Nigel wearing a Hellraiser helmet (23, 43) or Fabian dressed as a predatory bird (60). Califia associates rubber with the desire to blend into the impersonal and become more like a machine, although she acknowledges that there is also an association with dinosaurs. Futurism and the alien themes are strongly suggested, too, by the use of metallic costumes such as are found in Nicholas Sinclair's photographs of Nicola Bowery (22, 38) or Fia (27, 50, 51). Leather fashions, like the warrior woman costumes by Velda Lauder or Pam Hogg and Craig Morrison's cyberpunk and rubber-spiked costumes, also support such a view. Other perspectives held by some sado-masochists insist that leather corsets should only be worn by dominants and rubber ones by submissives.[67]

Colours, too, can alter personal reactions to materials. Fetish culture is strongly committed to black and to a much lesser extent red, both of which have strong cultural associations with night and blood, death and life, that lead to rich repertoires of associations. The use of other colours may cheapen the perception of materials or neutralise their sexual meaning and return their significance to the mundane everyday world.[68]

The nexus between fetish designers and *haute couture* is fluid, with designers like Vivienne Westwood beginning her career as an outside radical, but many other more established names raiding the culture for ideas and styles. Westwood's boutique Sex, on the King's Road, began to refocus fashion, publicly and explicitly, on sex and power with designs meant to taunt staid tastes by confronting society with what it had hidden and denied. This attitude is shared by successive generations of fashion students including Angela Murray, Stuart Vern, Gina Love, Kurt Veith, Michael Saint and Velda Lauder, who target their most creative wares to the fetish community, rather than the wider society. According to Valerie Steele,[69] fetishism has also emphasised extreme tastes and ignored fashion trends. Although such styles are frequently 'borrowed' by *haute couturiers*,[70] and

sometimes mass marketed, it is fetish culture that has heavily influenced society at large while successfully resisting attempts to tame and domesticate its creative zeal.

Regardless of the movement's growing importance and stature as a source of visual imagery, there has been an historical paradox in Britain, where despite the apparent openness and vogue for fetish culture, fashion and the advertising camapaigns of Dunlop, Levi's and even Liberty's and Burberry's, clubs have not escaped police harrassment. British fetish culture has also suffered the vicissitudes of legal actions which, in the case of the Spanner Case[71] – the most widely discussed – has helped to unite fetishism's diverse sections in the defence of victims of consensual SM and in the campaign for the repeal of censorship and other repressive laws.[72] There seems to be a dynamic between a soft and hard fetishism, in which society's playful manipulation of soft fetishistic images encourages more toleration of hard fetishism, while at the same time stimulating an increased and broader interest that seeps into mainstream culture, redrawing the line of socially acceptable behaviour and pushing transgression to redefine its aesthetics and practices.

Orders of desire

Central to fetishism is the manipulation and play of the human body. Science, in the late twentieth century, has divested the body of all its mystery and transcendental instrumentality, leaving it an empty, soulless shell of bone, viscera, flesh and blood. American and European civilisation has lost sight of the potentialities of the body by reducing it to a naturally functioning organism regulated by biological and chemical laws and enclosed by its diaphanous membrane of skin. Any metaphysical, aesthetic or sexual significance it might once have possessed is now denied or made irrelevant.

Fetishism constitutes a radical denial of this superficial and impoverished physiological model. Its manipulations of the body question and transgress the assumed naturalness of its boundaries, functions and gender. It is the staging of and the response to Foucault's tormented question of whether '… we truly need a true sex?' when '… one might have imagined that all that counted was the reality of the body and the intensity of its pleasure'.[73] Whether fetishism perceives its manipulations of bodily and emotional sensations as a means to transcend the body's ordinary material existence or as a non-transcendental physical refutation of that existence, it can claim strong and significant historical antecedents in medieval gnosticism and Victorian gothic-romanticism.

The view that the late medieval gnostics loathed and denied the physical nature of the body is no longer uncritically accepted. The gnostics thought the body was not so much the prison of the soul, but that part of the person which could undergo manipulation to permit

the soul's release from the limitations of the physical world. Europe, between the thirteenth and sixteenth centuries, was replete with accounts of the body being manipulated for religious purposes. Male and female saints were regularly described 'jumping into ovens or icy ponds, driving knives, nails or nettles into their flesh' or whipping or hanging themselves in sympathy with Christ's suffering.[74] Cases of unnatural bodily conditions and processes, miraculous wounds appearing on the living, arrested putrification of corpses and the presence of sweet perfumes being exhaled from dead bodies, as well as virgin pregnancies, miraculous lactations, diets based solely on the consumption of the eucharistic host (*inedia miraculosa*) and the idea that sickness and disease should be embraced as heavenly favours to hasten communion with the divine, all attest to the complex mingling of physical, spiritual, psychological and sexual attributes of the self caught in its upwards reach towards divinity. 'Women regularly speak of tasting God, of kissing Him deeply, of going into His heart or entrails, of being covered by His blood.'[75]

In some areas of thought, after partly merging sexual differences, the medievals even imagined Christ as alternatively man or woman, depending on whether the gender reference was to the bleeding and nurturing qualities of her flesh or his spirituality.[76] In one recorded vision, Christ was even described as having appeared as a crucified female and elsewhere, more extraordinarily still, 'as a dish completely filled with "carved-up flesh", like that of a child'.[77] The gnostics' regulation, discipline and manipulation or mutilation of the body was not, therefore, a sign of the rejection of the physical body but a means of producing an ecstatic catharsis which brought it into the divine presence.

Body is the instrument upon which the mystic rings changes of pain and of delight. It is from body – whether whipped into frenzy by the ascetic herself or gratified with an ecstasy given by God – that sweet melodies and aromas rise to the very throne of heaven.[78]

Two hundred years later, towards the close of the eighteenth century, the body also attracted considerable attention which by the late nineteenth century focused on defining its normative condition. The literature is too dense and complex to give any overview of the medical debates on changing concepts of bodily stasis or morbid pathology,[79] or its social regulation and cultural domestication and subordination within a highly structured patriarchal society,[80] but it remains relevant to look at the abominable or abject body, the man- or woman-like creature created and animated outside of and in opposition to God's grace. Vampires, zombies, werewolves, man-made monsters (Frankenstein's creature, the schizophrenic Mr Hyde) and, beginning with H.G. Wells, extra-terrestrial aliens, defy the

late nineteenth-century concept of the body's sanctity, ontologically, physically, ethically, morally and – particularly germane in the present context – sexually.

The monster around which the nineteenth-century gothic is centred share a large number of characteristic traits. Abject bodies are usually the result of unnatural, non-procreative birth or creation, brought about either through mutation (scientifically induced in the case of Frankenstein and Hyde), demonic intercession (penetration of the host body not by the penis, but the bite), or alien reproduction. Such bodies are unbaptised and are separated from and opposed to God's family (the undead are related to earthly filth rather than spirit, their lives unfold in the blackness of the night rather than the day, under the sway of the moon rather than the sun, and they are damned, cursed to restless existence). Lacking spirituality and being devoid of a soul, these bodies are animated either by some mysterious scientific force or principle (the electric charge) or supernatural anima. Any superficial 'naturalness' is always dispelled by unsociable behaviour stemming from amorality or violent antagonism against society (Frankenstein's creature and Hyde's criminality). Alternatively, their anthropomorphic form violates the boundaries of the 'natural' body (the vampire's transformation into animal familiars or mist, or the human mutation into wolf). These creatures share no family, community, ethnic or national affiliation. They exist on the cultural periphery (remote castles, isolated villages, ruined buildings, laboratories where unnatural experiments are performed) or in the wild untamed expanses of nature (forests, mountains, Arctic wastes). Finally, these transgressive creatures are often, either explicitly or implicitly, sexually voracious.

The visual language of the gothic is exploited widely in some of the portraits that Nicholas Sinclair has assembled. At different ends of the spectrum of taste and desire are Suzy (9,45,61), who assumes the costuming of the archetypal *femme fatale*, a paragon of the gothic dark lady, while Franko B (20,25,28,29,30,47) is engaged in his solitary exploration of the horrors of his entrapment in a physical body that limits his power of expression and forever threatens human longevity and wellbeing.

The supernatural and sexual elements of vampirism are particularly exploited in the, now dated, film scripts of Jean Rollin, the Hammer classic *Countess Dracula*, or in the overtly eroticised opening sequences to Tony Scott's *The Hunger*, not to mention the hordes of promiscuous heterosexual and bisexual vampiresses who habitually accompany their male counterparts and prey on 'normal' male bodies, male vampires who transform traditionally devout and faithful women into lustful seductresses, and the striking and imperious mates the film industry have from time to time created for Frankenstein's creature. Not only have performance artists such as Nicola Bowery (22,38) and Orlan sometimes echoed the iconography of such forbidden temptresses, but societies like the Velvet Vampires preserve

their fertile if romantic evocation for their devotees.

These figures of the abject, defiled and 'unnatural' bodily 'other' throw into dramatic relief the ethical social body used as a metaphor not only for the moral, judicial and Christian metaphysical person, but of family, community and nation; in short the social body, the family body, the body of citizens, the body politic consecrated under the divine protection of the ecclesiastical body and the church fathers. These uncompromisingly simple, strong and striking oppositions between the normal and the abject body, between isolation and family, nature and culture, bestiality and humanity, promiscuity and regulated sexuality, lie so close to the staging of fetishistic desire that it can be no surprise how the protagonists of gothic romance have effortlessly come to occupy an important part of the fetishistic imagination which likewise is based on a romantic rejection of mainstream culture.

While gnosticism in its techniques and view of bodily instrumentality could be seen as closely related to fetishistic sado-masochism and Modern Primitives (strongly evoked by Franko B, Dicky Dick, Xed Le Head and Darryl), a highly romanticised fetishism (Suzy, Fia, Fabian) may assume the melancholic imagery of gothic nostalgia. The gothic creation of the abject body nevertheless provides an alternative radical and readily recognisable image for a sub-culture opposed to mainstream sensitivities.

Whereas there are similarities and affinities between the gnostic idea of the instrumentality of the body or gothic's excessive stylisation and aestheticisation of the abject body and fetishism's ideas about ethics and aesthetics, neither philosophy is reducible to the other. Different concepts of the body exist within fetishism. Fakir Musafar's motivations for bodily manipulation such as constricting, sealing or suspending the body by use of restrictive instruments and clothing, gilding and fleshhooks, is intended to induce states of altered consciousness. While his views on the instrumental potentiality of the body share much in common with gnosticism, they also borrow elements from South Asian and Plains Indian religious practices which lead to his identification with Modern Primitivism.

The whole purpose of 'modern primitive' practices is to get more and more spontaneous in the expression of pleasure with insight. Too much structure somehow destroys any possibility of an ecstatic breakthrough in life experiences.[81]

While sympathetic to artists who manipulate their bodies solely for artistic reasons or SM practices based entirely on physical motivations, he nevertheless distances himself from them.[82]

Other factions of the movement – gay, lesbian, queer or heterosexual sado-masochists,

leather, rubber, PVC or other fetishists, and cyberpunks – discipline, reshape, manipulate and transgress the body's boundaries and reject morally sanctioned behaviour to achieve states of eroticised ecstasy. Nicholas Sinclair's photograph of Polly (44) shows her wearing a metal harness around her back which conflates the image of a large and menacing insect with the idea of an exoskeleton that turns our notions of the human body inside-out. In another photograph, Darryl (63), photographed after a performance at the Institute of Contemporary Arts, has converted his body into a religious icon by sewing crucifixes around his head, neck, torso and arms and attaching crystals and devotional objects, including a metal heart of the Virgin Mary, to his skin. The status and condition of his body is made ambiguous, leaving us unsure whether to see him as a devotional figure who should be regarded with piety or the excessive devotee of a bloody and cruel religion who elicits our pity. Practices and images like these not only have historical antecedents, previously discussed, but also contemporary and revealing equivalents.

Herbert Marcuse is perhaps the single most important philosopher to have influenced the sexual politics of the 1960s sub-cultures. The repression of the desires of the libido, he argued, did not originate in some biological drive that strove to subordinate them, as Freud had thought, but in a drive instituted by society which sought to domesticate and harness them to uphold its own exercise of power and authority. The politicisation and social control of the body was essential to subordinate its natural desire to lose itself in pleasure to the dictates of an exploitative social existence. The persecution of those involved in the Spanner case and the lawsuit brought against the late Mr Sebastian for his professional work in body piercing, reflect the threat that fetishism is seen to pose against the socially established means of policing individual human bodies and limiting the boundaries of permitted experiences.

The pleasure principle was dethroned not only because it militated against progress in civilisation but also because it militated against a civilisation whose progress perpetuates domination and toil.[85]

Marcuse goes on to say:

This process achieves the socially necessary desexualisation of the body: the libido becomes concentrated in one part of the body, leaving most of the rest free for use as the instrument for labour.[84]

Perverse sexuality, classified as anything that does not perform a procreative function, is

still seen as threatening the very foundation of society not only because of its focus on the extension of pleasure and its promise of greater rapture than anything offered by normative sexuality, but because it sets itself in opposition to the rational and utilitarian view of social existence.

Marcuse's sexual politics hold deep implications for our view of human nature and freedom. Although they have been previously explored in the context of 1960s art, they are equally germane to considering the political motivation behind some contemporary performance artists whose works are closely connected with issues related to fetishism.

Since the 1960s performance art has attempted to criticise mainstream notions of the secularised body, sex and related bodily taboos. Some of these artists, such as Annie Sprinkle and Fakir Musafar, have been active in the sex industries or fetish scene and have participated in both practical and political debates within the culture. Others, including Stellarc, Franko B and Orlan, have used their bodies to question or reject the West's political and ideological control and censorship over them. Franko B's disquieting performances involving the use of his own blood and orthopaedic supports is manipulated as a metaphor for the sustaining institutions that society uses to encage us. Annie Sprinkle's use of her clitoris is intended to demystify female sexuality as well as question the relationship between publicly visible anatomy and her subjective construction of her own identity.

According to the French artist, Orlan, who shares a concern with the basis of identity, surgical interventions, techniques of artificial insemination and modern medicines have already alienated and denaturalised the body, compromising both its organic integrity and purity. Any remaining concept of physical bodily integrity is nothing but an illusion created by an anatomical synthesis of idealised physiological templates combined from different real bodies. Her own work confronts the disingenuous bodily naturalism that society nevertheless attempts to uphold by transgressing the taboos surrounding its non-medical manipulation and asserting her own control over its outward appearance.[85] In the *Reincarnation* series, begun in 1990, Orlan uses surgery to assume the physiological features in the portrayals of five women, chosen not for their legendary beauty but for their womanly qualities that she feels encompass the full spectrum of female subjectivity: Diana, the chaste adventuress, lends Orlan her nose; the capricious Europa provides the model for the mouth; Da Vinci's Mona Lisa, the quintessence of androgyny, bestows her forehead; Botticelli's Venus, symbolising creativity and fertility, provides the source of the chin, while Gérôme's portrait of Psyche, beloved of Venus, lends her eyes. The operations are performed in theatrical sets and are recorded and televised to demystify them as private acts. Surgery is the way Orlan has chosen to negotiate and question the relationship between her interior personality or

selfhood and its representation in exterior appearances. She consciously demonstrates that the image of the ideal woman is unattainable and draws public attention to the physical horror of the process used by women to attain patriarchal images of female perfection.[86]

Another artist, less concerned with questions of the nature of human identity, focuses on the body's limitations and potential extendibility by means of technological and biological engineering. Using medical instruments, Stellarc has filmed the interior of his body and used sensors connected to amplifiers to render blood flow, muscle contractions and heart beats, into an 'acoustical landscape' (*Deca-Dance: Event for Three Hands, Sitting/Swaying: Event for Rock Suspension,* and *The Body Obsolete*).

The imagery of the suspended body is really a beautiful image of the obsolete body. The body is plugged into a gravitational field, suspended yet not escaped from it. My body was suspended by hooks with ropes from an 18ft diamond inflated balloon. My body sounds were transmitted to the ground and amplified by speakers. I got sick — turned purple — the body sounds changed dramatically.[87]

Whereas Orlan and Stellarc question the adequacy of the body for the late twentieth-century world of micro- or bio-technology, computerised information systems and robotics — an element also found in the aesthetics of cyberpunk — Fakir Musufar, along with many of the serious Modern Primitivists, reaffirms the instrumentality of the body in providing access to heightened or transcendental states of consciousness. In Musafar's words: 'Eroticism is the best possible way to reach God, to go into another world.'[88]

Although much contemporary performance art has a clear secular political motivation, earlier exponents shared with Modern Primitivists a more singular interest in restoring religion, ritual and sexuality into the spectacle. Early works were of two types. The first included the work of Hermann Nitsch and Carole Schneemann, who used the themes of fertility and animal sacrifice. Nitsch's pieces, performed in the 1960s, involved tearing apart and disembowelling a lamb or bull and covering the actors and the performance area in its blood and tissues in what has been interpreted as a staged revival of the Roman *sparagmos* festival or communion where revellers digested a bull representing Dionysus. In another production, a young male stood or lay beneath an animal carcass, marked with religious symbols, whose body slowly became covered and submerged in the animal's blood and guts. This performance was related to an initiation ceremony in which young men were bathed in the blood and entrails of a bull to re-emerge as the reborn deity.[89] Further productions, orchestrated by Nitsch's Wiener Aktionismus group with other performers, revolved around transvestism, self mutilation and sacrifice and the public transgression of taboos such as

eating excrement and vomiting – acts associated with diverse manifestations of shamanic practices in Asian and American societies.

A second group included Chris Burden who, with hands tied behind his back, crawled over broken glass (*Through the Night Softly*, 1973), Dennis Oppenheim who, for half an hour, allowed himself to be stoned (*Rocked Circle/Fear*, 1971), and Fakir Musafar and Stelarc, whose activities focused on shamanic magic and ordeal.[90]

The Modern Primitive movement has been defined by Fakir Musafar as describing '... a non-tribal person who responds to primal urges and does something with the body.'[91] More particularly, Musafar sees it as a turning inwards on oneself to develop latent abilities and powers.

> *Either they (societies) externalise, or they internalise. If they externalise, they develop tools which become technology or organised, rational science. That's what the Western culture is. Or, they can internalise and develop the other way, whereby they can do all kinds of physical things with magic. At this point in history, both approaches are starting to merge.*[92]

Much of Modern Primitivism appears not naïvely to imitate tribal practices from other parts of the world, but to synthesise residues or different parts of non-Western philosophies and religions, rituals (particularly those that can be interpreted as *rites de passage*, and techniques and styles of body adornment including scarification, tattoo and piercing. Thus, in the exhibition *Fetishism*,[93] responses of visitors with an active interest in the new Primitivist Movement to the gallery containing African power objects ranged from those who appeared timid in the face of such a perceived concentration of potency to those who sought to incorporate the meaning of such objects into their own understanding. In a performance at the Institute of Contemporary Art (*Deliverance*, 1995), Brian Murphy, Ron Athey and Alex Binnie painted their bodies with black grease paint, sprinkled with talcum powder (18), taking on the appearance of Nubian warriors or the New Guinea mudmen – an image made famous by the 1995 advertisement for Vauxhall cars.

Another performance artist who has close affiliations with the Modern Primitivists is Kim Jones, an American artist, who adopts costumes and body decoration that McEvilley has identified as consistent with shamanic practitioners.

> *In a performance in Chicago in 1981, Jones appeared naked except for a mask made of a woman's pantyhose, covered himself with mud (as both African and Australian shamans do when performing), and lay naked on the fire escape in the cold to accumulate energy... Returning to the performance space, he produced a mayonnaise jar filled with*

his own shit, smeared himself with it, embraced members of the audience while covered in it, and finally burned sticks and green plants till the smoke drove the remaining audience from the gallery.[94]

For these performers, who can be seen as an avant garde articulating the philosophy and imagery of Modern Primitivists, the art gallery assumes the status of the temple or sacred lodge, providing a protected space set apart from the normal spatial topography where such acts would meet fierce resistance, incomprehension, even reprisal. Nevertheless, performance art is less well grounded in any systematic or coherent belief system than that which many Primitivists would claim to support. Fetish clubs cannot usually compete with the protected spaces of galleries and art centres but the people captured in Nicholas Sinclair's photographs consciously, expressively and intelligently use self-display to question the world they have been told slavishly and uncritically to accept. They have, with all Pandora's mischief and imagination, re-expressed their individual and social identity while transgressively playing against the world of accepted appearances and behaviour.

Modern Primitivism is closely focused on re-empowering its adherents by returning to them their close relationships with their bodies and the forces of nature, and developing alternative religious and magical technologies through which to express and concentrate their activities. Performance art and Modern Primitivism share much in common, but spectacle, ritual and sexuality are consistently replete and recurring focuses throughout much of contemporary fetishism as well as art.

Surrealism, gnosticism and gothic romanticism share common strands that penetrate to the heart of fetishism's culture. Fetishism, like Surrealism before it, emphatically proclaims itself to be more than just a transgressive form of behaviour. By choice or accident, fetishism, by identifying itself with transgression, is itself an important and undeniable part of a far-reaching political and cultural critique of bourgeois being. Transgression, however, cannot exist independently of the limits whose boundaries it is forever destined to violate. It exists for mere moments before falling within an incessantly moving limit that tirelessly closes up behind it. Transgression is the essential component not only of an uncompromising creativity, but as Bataille himself recognised, its sexual expressions may even provide us with one of the very tares through which Divinity can reveal its presence. Transgression, like lightning, which Foucault saw momentarily forking across the night sky, 'gives a dense and black intensity to the night it denies, which lights up the night from the inside, from top to bottom, and yet owes to the dark the stark clarity of its manifestation, its harrowing and poised singularity; the flash loses itself in this space it marks with its sovereignty and becomes silent now it has given a name to obscurity.[95]

Footnotes

1 'A Preface to Transgression', in *Language, Counter-memory, Practice, Selected essays and interviews with Michel Foucault*, ed. Donald Bouchard, Basil Blackwell, Oxford, 1977, p.34

2 Herbert Marcuse, *Eros and Civilisation*, Abacus, London, 1969, p.34

3 Ted Polhemus and Housk Randall, *Rituals of Love, Sexual Experiments, Erotic Possibilities*, Picador, London and Basingstoke, 1994, p.14

4 Georges Bataille, *The Tears of Eros*, City Lights Books, San Francisco, 1989, p.20

5 Michel Foucault, *The History of Sexuality*, Penguin Books, Harmondsworth, 1978, Vol.1, p.139

6 Ann Laura Stoler, 'Carnal Knowledge and Imperial Power, Gender, Race and Morality in Colonial Asia', in *Gender at the Crossroads of Knowledge: Feminist Anthropology in the Postmodern Era*, ed. Micaela de Leonardo, University of California Press, Berkeley and Los Angeles, 1991

7 Anne McClintock, *Imperial Leather: Race, Gender and Sexuality in the Colonial Contest*, Routledge, London, 1995, p.45

8 This is not to suggest that there were not important political differences in the relationship, on the one hand, between male European colonisers and the women of those colonies and, on the other, between the colonisers and the women of their own ethnic group. Such distinctions could not help but prevent identification between these groups based on the plight of their exploited conditions.

9 McClintock, op. cit. p.42

10 Anthony Shelton, 'The Chameleon Body: Power, Mutilation and Sexuality', in *Fetishism: Visualising Power and Desire*, ed. A. Shelton, Lund Humphries, London, 1995, pp.26-9

11 See also *Taboo, Sex, Identity and Erotic Subjectivity in Anthropological Fieldwork*, Don Kulick and Margaret Wilson (eds), Routledge, London and New York, 1995

12 Shelton, op. cit.

13 Michele Richman, 'Leiris's *L'Age d'homme*: Politics and the Sacred in Everyday Ethnography', in *On Leiris*, Yale French Studies, No.81, Yale University Press, New Haven, Conn., 1992, p. 91

14 Dawn Ades, 'Surrealism, Fetishism's Job', in Shelton, op. cit. p.72

15 Albert Einstein, quoted in Dawn Ades, op. cit. p.67

16 Patricia Leighen, 'The White Peril and l'art Nègre: Picasso, Primitivism and Anti-colonialism', in *Arts Bulletin*, 722, no.4, 1990, pp.609-30

17 Shelton, op. cit. p.23

18 Michel Leiris, 'The Sacred in Everyday Life', in *The College of Sociology* (1937-9), ed. Dennis Hollier, University of Minneapolis Press, Minneapolis, 1988, p.24

19 ibid. pp.28-9

20 ibid. p.99

21 Georges Bataille, *Eroticism*, Marion Boyars, London and New York, 1987, p.22

22 Leiris's interest in the tight-fitting leather masks owned by Seebrooke is well known and has generally been accepted as indicating his interest in fetishistic eroticism. However, Leiris's original concern with these masks may have been related to his interest in sensory deprivation experiments

23 'Abject Art, Repulsion and Desire', in *American Art*, Whitley Museum, New York, No.7, 1993

24 Rebekah Wood, 'Auto-Erotica', in *Skin Two*, No.14, 1993, pp.66-7

25 Ted Polhemus explains it as a reaction to the AIDS epidemic or as a response to what he calls 'fantasy collapse', when the dreams that energise life fail to work. Polhemus and Randall, op. cit. pp.4-7

26 Quoted in Anne McClintock, 'Maid to Order', in *Skin Two*, No.14, 1993, p.70

27 ibid. p.71

28 ibid. p.70

29 J.C. Flugel, *The Psychology of Clothes*, Hogarth Press, London, 1930

30 Spencer Woodcock, 'The Tourist Path', in *Fetish Times*, No.5, 1994, pp.56-7

31 Maurice North, *The Outer Fringes of Sex. A Study in Sexual Fetishism*, Odyssey Press, London, 1970, p.68

32 ibid. pp.82-3

33 Polhemus and Randall, op. cit. p.59

34 Michael Bracewell, 'Leigh Bowery's Immaculate Conception', in *Frieze. Contemporary Art and Culture*, No.19, 1994, pp.38-43

35 Spencer Woodcock, '*Smutfest* 94', in *Fetish Times*, No.7, 1995, pp.13-16

36 Club Fantastic at the Vox, Brixton, 1995

37 Stephanie Jones and Tim Woodward, 'Safety Restrictions', in *Skin Two*, No.8, 1988, pp.38-41. Richard Shaw, 'The Bottom Line', in *Fetish Times*, No.6, 1995, pp.42-3. Spencer Woodcock, 'Get on Your Knees Bitch! Ideologically Sound Spanking and Political Correction', in *Fetish Times*, No.2, 1993, pp.25-8. Spencer Woodcock, 'The Tourist Path', in *Fetish Times*, No.5, 1994, pp.56-7. Also Fakir Musafar, 'The Corset and Sadomasochism', in *Sandmutopia Guardian. A Dungeon Journal*, No.11, nd, pp.14-16

38 Jean Paulhan, 'The Marquis de Sade and His Accomplices', in de Sade, Justine, Grove Press, New York, 1965, p.3

39 Simone de Beauvoir, 'Must We Burn Sade?', in de Sade, *The 120 Days of Sodom and Other Writings*, Grove Press, New York, 1966, p.4

40 ibid. p.64

41 Paulhan, op. cit. p.17

42 Illustrated publications of the American Nutrix Company in the 1950s, for example. See North, op. cit. pp.140-1. Also discussion in Gillian Freeman, *The Undergrowth of Literature*, Nelson, London, 1967, p.139

43 Jean Paulhan, Introduction to Pauline Réage, *The Story of O*, 'Happiness in Slavery', Grove Press, New York, 1965, pp.xxi-xxxvi

44 De Sade, *Philosophy in the Bedroom*, Grove Press, New York, 1966, p.185

45 Pat Califia, *Public Sex, The Culture of Radical Sex*, Cleis Press, Pittsburgh and San Francisco, 1994, p.205

46 O. Mirbeau, *The Garden of Evil*, David Bruce and Watson, London, 1973

47 ibid. p.61

48 Pauline Réage, *The Story of O*, op. cit. p.5

49 ibid. p.21

50 Jean de Berg, *The Image*, Grove Press, New York, 1966, p.124

51 Leopold von Sacher-Masoch, 'Venus in Furs', in Gilles Deleuze, *Coldness and Cruelty. Masochism*, Zone Books, New York, 1991, p.149

52 ibid. p.218

53 De Sade, *Philosophy in the Bedroom*, p.234

54 Mirbeau, op. cit. p.43

55 ibid. p.43

56 Miranda Raven, 'My Crystal Chamber', in *The Best of Skin Two*, ed. Tim Woodward, Masquerade Books, New York, 1993, p.131

57 See David Flint, 'Hollywood Babylon', in *Skin Two*. No.16, 1995, pp.52-70

58 Versions of de Sade's *Justine* have been produced by Jess Franco and Chris Boger (*Cruel Passion*). His *The 120 Days of Sodom* was adapted by Pier Paolo Pasolini (*Salo*). Just Jaekin directed *The Story of O*, and there are two versions of its sequel, *Return to the Château*, directed by Eric Rochat (*The Story of O. 2*) and Shuji Terayama (*The Fruits of Passion*). Jean de Berg's *The Image* was adapted by Radley Metzger as *The Punishment of Anne*. See Flint, op. cit.

59 Michelle Olley, 'Cleo Uebelmann, The Right Hand Path', in Woodward (ed.), op. cit. p. 67

60 Michelle Olley, 'Jean Paul Gaultier – Rascal of Radical Chic', in Woodward (ed.), op. cit. p.70

61 Valerie Steele, *Fetish: Fashion, Sex and Power*, Oxford University Press, New York and Oxford, 1995, p.51

62 Freeman, op. cit. p.152

63 North, op. cit. p.61

64 ibid. p.67

65 ibid. p.91

66 Califia, op. cit. p.194

67 Steele, op. cit. p.63

68 Califia, reconfirmed by Freeman, op. cit. p.127, in her analysis of correspondence to fetish magazines, 1991

69 Steele, op. cit. p.100

70 In the late 1980s these included Gaultier's flirtation with corsets and lace-up corset dresses and men's jackets, Thierry Mugler's corsets with spiked breasts, and others with nipple ring-like attachments. Steele, op. cit. pp.88-9

71 In 1987 four videos, reported to include extreme sado-masochistic scenes, were confiscated by police in Bolton. The subsequent investigation led to one hundred homosexuals being interviewed, forty-two of whom were arrested and sixteen sent for trial. Even though the videos were not made for commercial circulation and the protagonists were all consenting adults, eleven men received sentences of up to four and a half years for assault, and twenty-six others were cautioned for aiding and abetting assaults on themselves.

72 Among the extensive commentary, see particularly Tim Woodward and Michelle Olley, 'Are You a Criminal?', in *The Best of Skin Two*, ed. Tim Woodward, 1993, pp.49-56. Niki Wolf, 'Spanner Goes to Europe' and Kellan Farshea, 'Kellan Exercise for the Mind', both in *Fetish Times*, No.7, 1995, pp.4-5 and pp.27-8 respectively. Bill Thompson, 'Assault on Reason', in *Skin Two*, No.16, 1995, pp.89-93

73 Introduction to *Herculine Barbin*, Pantheon Books, New York, 1980, p.vii

74 Caroline Walker Bynum, 'The Female Body and Religious Practice in the Later Middle Ages', in *Fragments for a History of the Human Body*, ed. Michel Feher, Ramona Naddaff and Nadia Tazi, Vol.1, Zone Books, New York, 1989, p.163

75 ibid. p.168

76 ibid. p.176

77 ibid. pp.161

78 ibid. pp.170-1

79 See Georges Conguilhem, *The Normal and the Pathological*, Zone Books, New York, 1991

80 See McClintock, op. cit., Foucault, op. cit.

81 Fakir Musafar in *Modern Primitives. An Investigation of Contemporary Adornment and Rituals*, Re/Search 12, San Francisco, 1989, p.13

82 Kristine Ambrosia and Joseph Lanza, interview with Fakir Musafar in *Apocalypse Culture*, ed. Adam Palfrey, Feral House, Los Angeles, 1990, pp.107-17

83 Marcuse, op. cit. p.45

84 ibid. p.49

85 Barbara Rose, 'Is It Art? Orlan and the Transgressive Art', in *Art in America*, February 1993, pp.82-7. Beate Ermacora, European Photography Art Magazine, No.56, pp.15-38

86 Rose, op. cit. p.125

87 Arthur and Marilouise Kroker (eds), *Body Invaders, Sexuality and the Postmodern Condition*, Macmillan Education, Basingstoke and London, 1988, p.26

88 Ambrosia and Lanza, op. cit. p.108

89 Thomas McEvilley, 'Art in the Dark', in Palfrey (ed.), op. cit. pp.70-1

90 McEvilley, op. cit. p.72

91 Musafar, op. cit. p.13

92 ibid. p.9

93 *Fetishism*, curated by Anthony Shelton, Dawn Ades and Roger Malbert for South Bank Touring Exhibitions and shown at Brighton Museum and Art Gallery, The Sainsbury Centre, University of East Anglia, and Nottingham Castle Museum, 1995

94 McEvilley, op. cit. p.74

95 'A Preface to Transgression', in Donald Bouchard (ed.), op. cit. p.35